Hand Lettering for SELF-CARE

Calligraphy Projects to Inspire
Creativity, Practice Mindfulness,
and Promote Self-Love

Lauren Fitz...

ULYSSES PRESS

Published in the United States by:
Ulysses Press
PO Box 3440
Berkeley, CA 94703
www.ulyssespress.com

ISBN: 978-1-64604-243-2
Library of Congress Control Number: 2021937818

Printed in the United States by Versa Press
10 9 8 7 6 5 4 3 2 1

Acquisitions: Casie Vogel
Managing editor: Claire Chun
Editor: Renee Rutledge
Proofreader: Barbara Schultz
Front cover design: what!design @ whatweb.com
Cover art: © Lauren Fitzmaurice
Interior design: Jake Flaherty

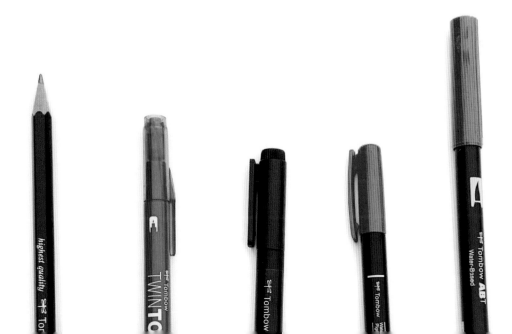

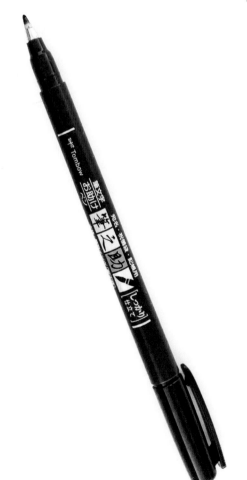

Introduction

MY LETTERING STORY

Life is full of twists and turns, stressful days, relaxing nights, laughter, celebration, and so many emotions. We set goals and experience trials and tribulations, achievements, and failures. Sometimes there is a fine line between surviving and thriving. That's why, through all that life brings, it is so important to focus on yourself, spending time on activities you love. So when life gets tough, I get a…brush pen. What, I'm the only one? Not for long!

I embarked on the hand-lettering path in the wake of one of the longest years of my life, when I felt completely burnt out and overwhelmed. At five days old, my youngest son, Miles, had undergone open-heart surgery because of a congenital heart defect. He fought and came out of the surgery stronger than ever, which rubbed off on this mama, who spent the next year trying to make sure that he, my other son, Mac, and my husband, Mike, were okay. Doctor's appointments…check. Dinner…check. Productivity at work…check. Time for myself, however, was nonexistent. It was easy to see that all of my energy went into taking care of everyone else and all of my responsibilities.

After 12 long and exhausting months of trying to be the "perfect" mom, I stumbled upon some posts about calligraphy on Instagram and was immediately intrigued. I had very little knowledge of self-care and was never really that great at it but really felt like I needed a change or something positive to focus on. I didn't realize the self-care aspects of calligraphy at the time. I have always been that girl who has way too many things on her plate and is always looking out for others, but I was in desperate need to find something for myself to focus. In passing conversation with my mom, I mentioned wanting to learn calligraphy as a hobby, and she kindly bought me an online calligraphy class as a gift.

I started lettering, and at first I was terrible and became frustrated easily. But the more I practiced, the less I focused on the stresses and worries of my life. The reward of learning a new skill exceeded my expectations while putting a little pep in my step. As days passed and my lettering skills improved, I found that

I was not only taking time for myself, but I began healing too. I felt energized and began sharing my work not only on Instagram, but in all areas of my life. When further challenges came my way, like my son's second heart surgery and other difficult times I encountered, I had a way to cope and find strength through reflection and creativity. Dark times weren't so dark anymore. Words and creativity brought hope and encouragement when I needed them most.

Over six years later, I have taught hundreds of people how to letter and love sharing my heart for lettering with everyone I meet. However, the most important person I letter for is still myself. No matter how busy I get or what life throws my way, I know I can overcome it with a little bit of hope, some positive words, my sketchbook, and some lettering supplies.

My hope is that this book can help *you* choose joy during all of life's seasons. Take a little lettering break with me! Grab a cup of coffee (or whatever your choice of creative juice), find a comfy spot, and let's get started.

FREQUENTLY ASKED QUESTIONS

I know, I know, you aren't sure lettering is for you just yet. Can lettering truly be a source of self-care and relaxation when it is so brand-new and foreign to you? Yes! It's okay to have questions and be unsure, but let's go over a few frequently asked questions before we dive in. Hopefully the answers to these questions give you confidence and clarity on what actually goes into lettering and calligraphy and your ability to learn this new skill.

Can I Actually Letter?

Lettering is the art of making beautiful letters with a variety of tools. There's a common misconception that you have to have good handwriting or be artistic to do lettering or calligraphy, and this just isn't true. Lettering is a learned skill that uses muscle memory to create creative and consistent letters from lots of practice over time. The beauty of hand lettering is that it is created by hand and isn't meant to look like a font. I like to think that there is perfection in the imperfections. Though there are lots of different brush pens and tools out there specifically for the art of calligraphy, you can create hand lettering with any pencil, pen, or marker you have.

Can Lefties Learn Hand Lettering?

Yes, they can! I'm actually left-handed. Though it wasn't super-easy to learn, I was able to master the skill, and so can you. To guide you in this endeavor, I've included little tip boxes just like this one throughout the book specifically for my lefty friends. If you aren't a lefty, a few of these tips may actually apply to you too. Don't worry, lefties, I've got your back!

THE RULES OF HAND LETTERING FOR SELF-CARE

To enjoy the benefits of hand lettering for self-care, you have to be able to follow the rules. Don't worry, they aren't too strict but are really important in creating a healthy and safe space for you to be mindful, creative, and reflective.

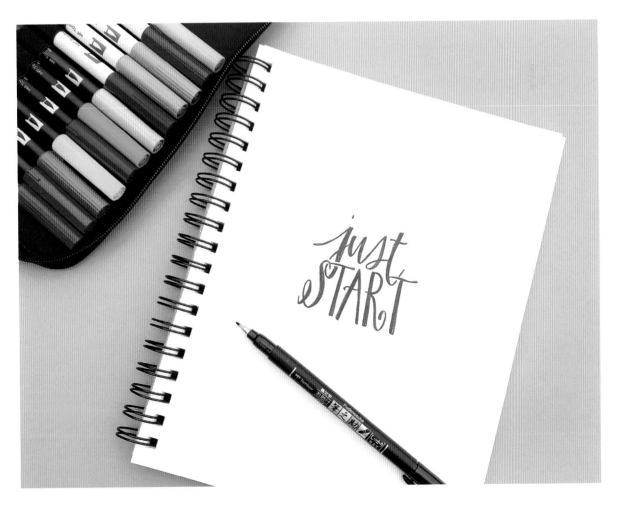

1. Just Start

Simply pick up your pen and get going. If you are waiting to be perfect or to find a better way to learn, all you are doing is spending time worrying when you could be creating. Especially in the beginning, you won't always love what you create, but the most important part is to start creating. The more you practice, the more inspiration will come your way.

2. No Comparison Allowed

We all do it, including me. It's so easy to hop on Instagram, see what other people are creating, and instantly go to that place of not feeling good enough. You are worthy to hold that brush pen, friend. Just think of it like this: Everyone is in a different place on their lettering journey. Some are in the beginning, and others have been on the road longer, but at one time or another, every single lettering artist was a beginner. Believe me when I say, the posts I shared at the beginning of my lettering journey were *not* what I would call great work. However, it is so cool to see how much I have grown in my lettering. So instead of comparing yourself to others, focus more on your progress and lettering that makes you happy.

3. Keep It Positive

Words are powerful tools. They can tear us down or build us up. One of my most favorite lettering projects is writing out quotes that I relate to and am inspired by. When you are lettering and creating, keep your pen, heart, and words happy, light, and positive. The work that you put out into the world has the ability not only to bring smiles to others, but also to lift your own spirits too. Write what your heart needs you to, and stay away from topics and ideas that bring you down.

4. Make a Little Time Every Day

Learning any new skill takes time, but sometimes there aren't enough hours in a day to fit in everything we want and need to accomplish. The amazing thing about hand lettering is that you can practice for just 10 minutes at a time and still improve and grow. So carve out a few minutes to create each day. Whether it is at 5 a.m. while you are waiting for your coffee to brew, during your lunch break, or late at night after your kids are asleep, the time you save to let yourself letter will never be time wasted.

5. Letter for You

Always remember, no matter how good you get at lettering or how fancy you write, you started this hobby for *yourself.* Letter what makes you happy and only choose to create projects that bring you joy. Don't let your projects for others fill up too much time. Make sure to always keep time for yourself to just create—no strings attached.

If you follow these simple rules and let yourself letter, hand lettering can be a great way to show self-care.

Hand Lettering for SELF-CARE

HOW TO USE THIS BOOK

You are probably wondering how this book is designed to help you on your hand-lettering journey. The goal of this book is to introduce you to the art and hobby of lettering while keeping self-care at the forefront and as your number one priority. The book is divided into three different parts, each with a specific and intentional purpose guiding you through not only learning hand lettering but also how to create, practice, and take time for yourself, create projects, and share your work with others.

Part 1: Let Yourself Learn

This section of the book will teach you all about the basics of lettering and how to set yourself up with a routine to learn and practice in a less stressful, at-your-own-pace way. I'll spare you the scary parts of starting a hobby by telling you exactly what materials and step-by-step information you need to get started.

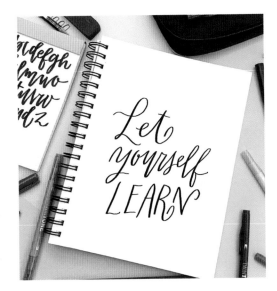

Grab a pen and a notebook and take some notes as you read this section, or refer back to it as you begin practicing and growing as a letterer. Tracing paper will also come in handy as you gather your supplies and get started in your learning, as there are many traceables (yes, that is a word) throughout this section of the book that will help you learn new styles and techniques.

Part 2: Let Yourself Letter

Once you learn the basics of lettering, it's all about the practice. With self-care as the goal, this part of the book will give you so many ways to practice your lettering for a variety of different reasons. Every day brings new excitement, goals, and challenges; the exercises in this section will help you focus on yourself and what is in your heart each and every day. You'll follow simple lettering tutorials to create some pretty awesome pieces in your sketchbook. Learn new styles and trace simple quotes using tracing paper on the themed traceables throughout the chapter. If you need more inspiration, this section includes amazing lists of creative prompts built around a specific purpose. So schedule those lettering breaks, keep an open mind, and get ready to have some fun.

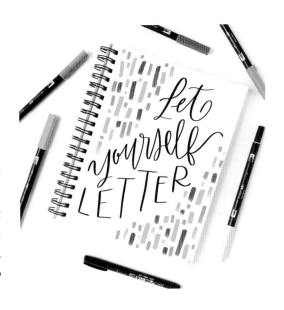

Part 3: Let Yourself Create

After you let yourself learn and practice lettering, it's time to turn your knowledge into creativity. In Part 3, you will graduate from letter to project, taking your skills of lettering on paper to additional surfaces to create amazing projects to enjoy and share with others.

WHAT ARE YOU WAITING FOR?

So dive on in and be ready to learn with an open mind and heart. It's easy to put off time for yourself, but you are definitely worthy of a break. You'll be amazed at what you learn, how you grow, and how gaining this new skill can truly add to and enhance so many areas of your life. What are you waiting for? Well... I'm waiting for you to get started with Part 1. Let's learn together!

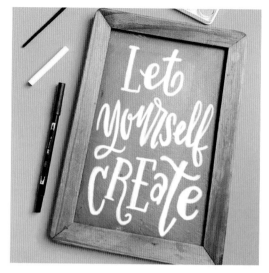

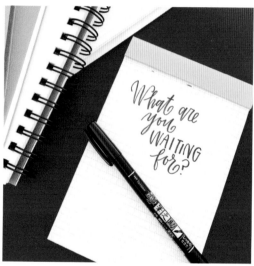

Hand Lettering for SELF·CARE

PART 1

It can be easy to sit down with brand-new lettering tools and expect to create beautiful lettering from the beginning, but that's not realistic. It's important to dedicate time and energy to understand a new skill before diving right in. Take time to let yourself learn.

Let yourself LEARN

Chapter 1

Lettering BASICS

WHAT EXACTLY IS LETTERING?

You may be thinking, "Okay, let's learn some lettering… Oh wait, what is lettering anyway?" As I mentioned earlier, lettering is the art of creating pretty letters with any pen or art tool. You've probably heard the words "lettering," "handwriting," and "calligraphy" thrown around interchangeably, but the truth is that they really aren't the same thing.

Handwriting is the way that you usually write print or cursive letters. You've been practicing this way of writing since you were a little kid, and your handwriting has evolved through the years. You may not think that you have great handwriting, but this won't affect your ability to learn lettering or calligraphy.

A huge umbrella with so many different types of the art form falling underneath, lettering is a blanket term for any kind of decorative, creative, or aesthetically pleasing creation of letters, ranging from bubble letters to the fanciest form of calligraphy.

Calligraphy is a specific form of lettering created by the application of pressure on a special pen to create thick downstrokes (any part of the letter where your pen goes down while writing is called a downstroke) and thin upstrokes. This book mostly addresses brush calligraphy and lettering that you can create with a regular pen or marker, but you can also use it to create other forms of calligraphy too, including watercolor brush calligraphy and pointed pen calligraphy.

Now that you know the difference between handwriting, lettering, and calligraphy, it's important to understand that there is no 100 percent correct or perfect way to create any form of lettering. No matter

Hand Lettering for SELF-CARE

what you are writing or how you are writing it, the beauty of lettering is that it is handmade, so it's okay for your work to look more like a human made it and less like a font. Wouldn't it be super-boring if we all created letters the same way? Embrace the perfectly imperfect and keep an open mind as you start to create.

WHERE DO I START?

Getting started in lettering can be a little overwhelming. Remember, you are lettering for self-care, so go into the process with the realization that you are learning a brand-new skill. It's fine to look on Pinterest and Instagram for inspiration, but don't get too caught up on what is out in the world. There are so many great resources and inspiration available right at your fingertips, but you can easily find yourself feeling like you are drowning in all of the options and getting stuck in the comparison game. It's best to keep it simple.

Start with the basics and build on your skills a little at a time. So start by just starting! Pick up the pen, get out of your comfort zone, and let yourself create. If you aren't sure what tools to buy or skills to practice, don't worry! I've totally got your back and will break down exactly how to learn lettering with only the tools you actually need and in a way that helps you relax and care for you.

THE RIGHT TOOLS, THE RIGHT WAY, THE RIGHT STYLE

I remember how it felt to start lettering, completely overwhelmed by all of the choices of lettering supplies. There I was, in the middle of the craft supply store, not having a clue what pens to purchase. I filled my cart with every brush pen and calligraphy item that I could find. Getting home and trying to figure out how to use them, I felt totally frustrated that it wasn't as easy as it looked on social media. It took *lots* of trial and error and practice on my part to figure out not only how to use the different kinds of pens and supplies, but also which ones were the best. So here I am after nearly half a decade of calligraphy and lettering practice to take away the anxiety and guess work.

Sure I have my favorite lettering supplies, which I'll share with you, but you don't need any fancy pens or materials to get started. All you really need is a writing utensil and paper. So grab whatever you have around you; it will work fine. While the better-quality tools that you have and the knowledge of how to use those tools well does matter and enhance your work in the long run, when lettering for self-care, it's more about the action and reflection taking place while completing the hobby. You aren't striving for perfection. Remember that you are lettering for YOU, and the most important thing is that you are taking the time to stop and create art about things that matter, so don't waste time stressing about the materials.

The Ideal Lettering Tool Kit

You don't need a million art supplies to get started lettering, but there are some common art tools in the lettering and calligraphy world that you can familiarize yourself with as you learn this new skill or expand the knowledge that you already have.

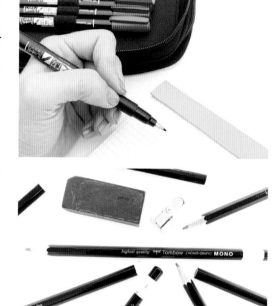

Start by adding the following tools to your toolbox.

Pencils

The perfect tool to get you started, pencils are extremely versatile to use for lettering. You can sketch with them and even practice how to create pressure to form upstrokes and downstrokes in calligraphy. The best part of pencils is also kind of obvious: *They are erasable*, so there is no risk or stress when lettering with a pencil.

My favorite pencils are drawing pencils, specifically Tombow MONO Drawing Pencils. They come in different grades of darkness, and this makes them so great for a variety of purposes. They start at grade 5H (super-light and perfect for sketching) and go all the way to 6B (dark and soft lead that is perfect for applying pressure during calligraphy and lettering practice).

Fine-Tip Pens

Fine-liner pens are perfect for thin-lined lettering and adding details and embellishments. These pens come in a variety of thicknesses to create different types of fine lines.

I always include Tombow MONO Drawing Pens in my tool kit. I use them to help create my artwork but also love how it's easy to just pick them up to doodle an idea or make a quick little note.

There are countless pen options out there that are also perfect for lettering, so have fun with it, and if you see a fun pen, pick it up and give it a try.

Hand Lettering for SELF-CARE

Broad Tip Markers

Markers with a conventional tip are probably the most common lettering tool out there. Snag some at pretty much any store or probably in a drawer in your house and use them in lettering in a variety of different ways.

When it comes to colored markers, I love Tombow TwinTone Markers. They come in several bright colors and have a small, broad tip with a fine tip on the other end. These water-based markers also blend really well and are great for all kinds of lettering and art.

Permanent markers are ideal for adding lettering to all manner of surfaces for a multitude of projects. You probably have a Sharpie lying around, which is great to throw into your lettering tool kit, but another favorite of mine is the Tombow MONO Twin Permanent Marker, which has two tips—one broad and one fine. The tips on this marker are the perfect size for smaller lettering.

Brush Pens

One of the most common and convenient calligraphy tools is the brush pen. The flexible brush tip creates thick and thin lines depending on the application of pressure. It can be tempting to pick up a brush pen first before using any other tool, but it's so important to understand the correct way to use them not only to lengthen the life of your brush pens, but also to create calligraphy with true, thick downstrokes and thin upstrokes. Brush pens must be held at a 45-degree angle and should be used on smooth paper to maintain the shape of the pen tips. Brush pens are definitely difficult to use at first but with a little practice and trial and error they become much easier to control.

Small Brush Pens: There are many different kinds of small brush pens, but my favorite are the Tombow Fudenosuke Hard and Soft Tip Brush Pens. I recommend the hard-tip brush pen for beginners as the firm tip is easier to control. Holding it at the appropriate angle with varied pressure, you can create thick and thin lines for smaller letters perfect for small quotes, sketch notes, and even envelope calligraphy.

Large Brush Pens: The Tombow Dual Brush Pen is a very versatile brush pen that has a flexible tip and water-based ink, which means that in addition to making larger calligraphy, it can be used as watercolor and blended in lots of really fun ways.

Water Brush

The water brush is a super-fun lettering tool that mixes the art of brush lettering with watercolor. This lettering tool can come in a variety of brush sizes. You unscrew the body of the pen and place water inside, then put it back together. The water brush works the exact same way as a large brush pen; however, the bigger or longer the brush, the harder it will be to control.

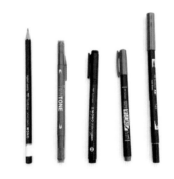

LETTERING STYLES

Before attempting to gather all of the different lettering supplies that you need, it is important to understand the style and form of lettering that you would like to create. There is definitely a learning curve when it comes to figuring out how to use certain lettering tools to create specific styles. Use the lettering tool guide as a reference for the easiest tools to start with. I always say to start with a pencil and work your way to more difficult tools that take more skill to use, such as the large brush pen.

Here are a few lettering styles and the best lettering tools to implement them.

Sketching & Lettering Practice

As already mentioned, the pencil is such critical tool. When it comes to lettering styles, the pencil does it all; it is ideal for creating sketches and practicing calligraphy and lettering skills. I recommend using a pencil when you are struggling with a specific skill, style, or tool.

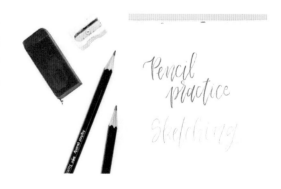

Monoline Lettering & Faux Calligraphy

Need a quick and easy style to use with practically any lettering tool? Try monoline lettering and faux calligraphy! Monoline lettering is simply creating script or letters using the single stroke of a marker or pen. Faux calligraphy is simply adding hand-drawn downstrokes to monoline lettering to create the look of calligraphy, which has thick downstrokes and thin upstrokes. All of the lettering tools that you could dream of can create these two styles with ease.

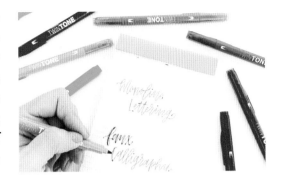

Serif & Sans Serif

Serif and sans serif styles are what I call "block letter" fonts with all letters in caps. The difference between the two styles is sans serif is a plain font while the serif font has added little serifs, or decorative marks, to enhance the look of the letters, making them look more like a font. Like monoline lettering and faux calligraphy, any lettering tool can be used to create these styles.

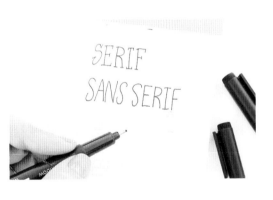

Brush Calligraphy

This brings us to brush calligraphy, the most popular style by far, but definitely the one that takes the most patience and perseverance to learn. Small brush pens and large brush pens can be used to create this style of lettering. It is imperative to understand how to use a brush pen well before attempting any style of brush calligraphy.

Now that you understand the skill and style involved with using lettering tools, it's time to figure out what to write on! Who's ready for paper?

Creating calligraphy with a brush pen is very different from lettering with a regular pen or marker. Since the tip is flexible, the pen must be at a 45-degree angle from the paper to create the thin upstrokes and thick downstrokes that make up calligraphy. The key to lettering with a brush pen is holding it farther back, away from the tip. This will feel a bit unnatural, but when you hold it correctly, it will be obvious from the beautiful strokes you will be able to make.

Once you find the perfect angle with which you are able to apply the right pressure to achieve thick and thin strokes, pay attention to the part of the pen where your fingers are gripping. For example, I grip the Tombow Dual Brush Pen along the back, beside the picture of the brush on the pen, and the Tombow Fudenosuke Brush Pens on the silver line on the body of the brush pen, between the logo and pen tip.

After you figure out how to hold the pen, you are well on your way to creating beautiful brush calligraphy.

Paper, Paper, Paper

It may sound obvious that you need paper for lettering, but it really is an important component of learning and practicing the art form. However, when it comes to lettering for self-care, the important thing is that you have paper. It doesn't really matter what kind of paper that you have if you are just getting started with a regular pen or marker, but there are specific types of paper that work best for certain types and purposes of lettering.

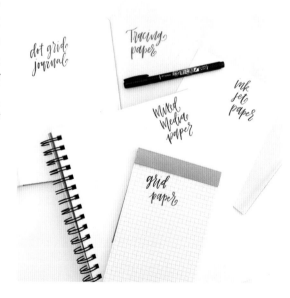

Sketchbooks and Journals

It's important to love what you are spending time to letter in. Sketchbooks, notebooks, journals, and note-pads come in all kinds of fun and cute shapes, colors, and sizes. When you see one that makes you happy, go on and pick it up. You will for sure find a way to incorporate it into your lettering practice.

Sketchbooks are a great way to keep your lettering practice and ideas in one place throughout your journey. They can serve as a type of anthology or journal of all the words, thoughts, and experiences that you go through while learning to letter. Loose paper is great too, but there is nothing like flipping through sketchbooks to see how you've grown in your skills while remembering what life tossed your way at different times.

Grid Paper

Grid paper is awesome for practicing your lettering, especially when you are learning a new lettering style or planning out a design for a quote. The paper has tiny little squares that make it super-easy to make your letters a consistent style or size.

Dot Grid Journal

Slightly different from grid paper, a dot grid journal has tiny little gray dots that create a grid without the lines, so it has a little less structure drawn on the page. Use it the same way you would grid paper. The dots are so light that your lettering will really pop on the page, but you can still benefit from guides to help create straight lettering and consistent designs.

Tracing Paper

The hidden secret to learning lettering, especially at the beginning, is tracing paper. The thin paper is perfect to fit over any worksheets or traceables (and over the pages of this book!). Fill pages and pages with letters and don't worry about wasting your precious sketchbook pages on practice.

Inkjet Paper

HP Premium Inkjet Paper is one of my favorite papers for brush pen lettering practice. The smooth surface makes it one of the only types of printer paper ideal for brush pens as it will protect the tips and prevent fraying. It is also an inexpensive option for creating new pieces and continuing to practice.

Mixed Media Paper

Many of my sketchbooks are filled with mixed media paper. This paper is great for so many different kinds of lettering tools. The thick pages also make it easy to incorporate watercolor or other artistic elements with your lettering.

Note: While all of the papers I have mentioned are fine to use with brush pens, it's important to make sure that you always use your brush pens with super-smooth paper. Regular printer paper is a great option for other markers and pens and may be what you have available, but looking into all of the above options is definitely essential if you plan to use brush pens.

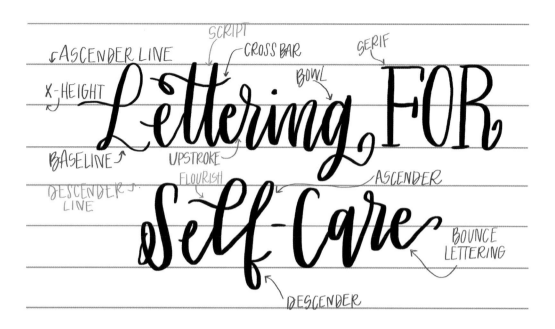

SPEAKING THE LANGUAGE OF LETTERING

Yes, lettering has its very own language and vocabulary. Don't worry, I'll help break it down for you. When it comes to the jargon of this fun little hobby, it doesn't have to be overwhelming, so let's work on the basics.

Lettering for Self-Care: creating beautiful letters to make your heart happy while not getting caught up too much in rules or the language of lettering.

Ascender: part of a letter that extends above the x-height.

Ascender Line: the invisible line marking the height of ascenders in a letter.

Baseline: the invisible line where your letters rest; descenders extend from this line.

Bowl: the closed, curved part of a letter.

Calligraphy: the art of producing decorative handwriting with thin upstrokes using a pen or brush.

Crossbar: a horizontal stroke that intersects part of a letter.

Descenders: part of a letter that extends below the baseline.

Downstroke: the thick part of a letter made by your hand as it applies pressure and moves down the page.

Hand Lettering for SELF-CARE

Entrance Stroke: Any stroke that begins your lettering.

Exit Stroke: Any stroke that ends your lettering.

Flourish: a decorative stroke added to a letter's ascender, descender, or crossbar.

Grip: the way the pen is held.

Kerning: the spacing and consistency in a group of letters.

Lettering: the art of drawing letters in a certain style or creating faux calligraphy by drawing in thick downstrokes.

Upstroke: the thin part of a letter made when your hand releases pressure and moves up the page.

X-Height: the invisible line marking the middle of an uppercase letter and top of a lowercase letter.

LEFTY TIP

Lefties can grip the pen in two ways

Overwriting: a grip where the wrist is curved over the lettering.

Underwriting: a grip where the wrist is straight below the lettering (most righties use this!).

Chapter 2

Learn & PRACTICE

FIVE STEPS TO JUMP-START LETTERING FOR SELF-CARE

It's official. You've read all the basics and are ready to jump headfirst into the world of lettering for self-care! Woo hoo! Now comes the fun part: learning and practice. When learning any new skill, it's important to keep in mind that it takes time and can begin with feelings of frustration and defeat. Don't give in. Take it step-by-step and let the process be a beautiful thing that you focus on *just for you*! Adding a little challenge doesn't have to be stressful.

There are five different steps to learning lettering. It's super-important to remember these five steps when learning to use any new lettering tool or style. The process of learning and practicing can take a while. When trying something new, always go back to step one and work your way forward. This will make the process of learning cohesive and enjoyable.

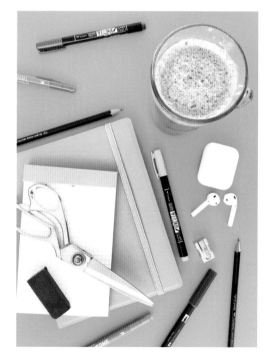

Hand Lettering for SELF-CARE

Step 1: Set a Routine

You may want to just start lettering, but this can prove extremely overwhelming if you aren't careful. Remember that this new hobby is for *you*. It will be vital to set a self-care lettering routine to keep yourself on track and accountable as you learn and grow in this new skill. Your lettering routine doesn't have to be super-structured or set in stone. Clarifying the following Five W's should guide your lettering journey and keep you focused on the goal of self-care.

Who

If you look in a mirror, you will see who you are lettering for. Keep yourself a major focus and priority as you learn, grow, and create. What, when, where, and why you letter should *always* make you feel happy. You are always caring for others, so make sure as you set the rest of your routine that you are making choices that are best for you.

What

You know that you want to learn lettering, but what are your specific goals? Is there a certain style or lettering tool you'd like to master, or a project you want to be able to create? Start small and decide what lettering tools and tasks you are ready to tackle, then work your way toward your ultimate goal.

When

Time is a huge factor in self-care. I've always heard that you can tell what a person values by how they spend their time. We've all wished for there to be more hours in a day. The worst feeling in the world is watching a day come to an end and feeling like you spent literally zero time doing something that you enjoy. Decide when and how long you want to practice lettering, then set aside that time and stick to it. Whether it is 15 minutes every morning, an hour each night, or a certain time during the weekend, make sure to honor and protect that time in your schedule. Pencil it in on your planner or set a reminder on your phone, and truly allow yourself to enjoy the time you have with yourself.

When I first started lettering, I lived for the time at night after my sweet boys were asleep and my husband was engrossed in a little TV to practice my new hobby. I originally set a goal of lettering each night for one hour, and this time quickly grew to several hours and often resulted in me having to make myself go to bed to get some rest.

Where

An important part of your lettering routine is definitely where you plan to learn and practice lettering. Maybe it's your kitchen table, like where I got my start, or maybe it's in a different spot in your home or a specific place that you love. Wherever you letter, make it somewhere that you'll be able to focus and be successful.

Why

We all have a why—something that inspires and drives us to do more, be more, go for more. It's crucial to think about your purpose for lettering. Each day when you sit down, what is *your* why? Do you want to learn something new about lettering to improve? Do you want to letter about something specific going on in your life as a way to cope or reflect? Or maybe you simply want to have a little fun. No matter your why, it's definitely important to keep in mind as you establish a routine.

Now, Go!

Once you have your routine established, you are truly ready to take off and start learning! Give yourself a little grace and hold back any pressure. Keep it light, fun, and exactly what you need to "fill your cup" each day. If you notice that your routine isn't working for you, make a change and always remember to focus on lettering for yourself. Dedicate a few minutes whenever you can to let yourself letter. You won't regret the time you put into making this new habit a daily routine.

Step 2: Learn Drills & Basic Strokes

It can be tempting to pick up a pen with the intention to letter words and phrases beautifully from the get-go, but that isn't the way it works. In order to be able to write consistent letters, it is so important to first practice lettering drills, which are the basic strokes that make up letterforms. Since lettering is learned through muscle memory, the consistency of a handwriting style comes from making parts of each letter in the same way. Though these lettering drills are most commonly used when learning brush calligraphy or any script style, they also come in handy when creating other kinds of lettering styles, such as serif and sans serif styles. Lettering drills are *always* a great place to start. Revisit them as you come across specific letters or styles that you need to improve.

Your approach to lettering drills will definitely depend on the lettering tools and style you choose to learn. For an ordinary tool like a pencil, pen, or marker, focus on creating the shape of the basic strokes in a consistent way. For a brush pen or similar tool, make sure you apply enough pressure to be able to see the difference in your upstrokes and downstrokes.

Once you feel confident in your ability to create consistent basic strokes, you will be ready to move on to the next step!

Drills and Basic Strokes

Now it's time to practice! Grab your lettering tool of choice and some tracing paper, and get ready for some fun! Use the traceables and fill pages with your basic strokes. Make sure to trace the drills that go with the appropriate tool.

Hand Lettering for SELF-CARE

Lettering Drills
The building blocks of letters

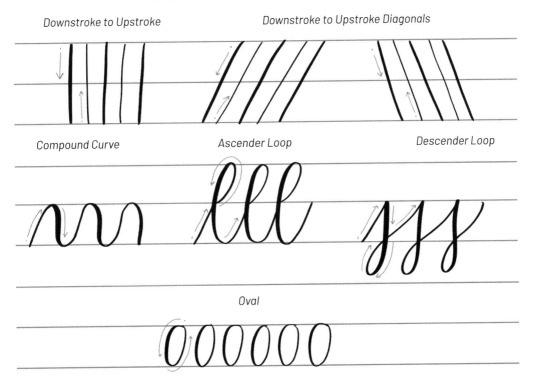

Downstroke to Upstroke

Downstroke to Upstroke Diagonals

Compound Curve

Ascender Loop

Descender Loop

Oval

Downstroke to Upstroke Drill

- **How to create:** Make straight lines down from the ascender line to the baseline, then up from the baseline to the ascender line.
- **Stroke importance:** The upstroke and downstroke are in many letters, and practicing them helps you to become more consistent in the upstrokes and downstrokes in brush calligraphy.

Downstroke to Upstroke Diagonals Drill

- **How to create:** Make diagonal lines down from the ascender line to the baseline, then up from the baseline to the ascender line.
- **Stroke importance:** Most capital letters have diagonals, such as A, M, N, V, and W.

Compound Curve Drill

- **How to create:** Starting at the baseline, slowly curve to the right when reaching the x-height. Then slowly add pressure as you go back toward the baseline.

- **Stroke importance:** Many lowercase letters have the compound curve, including a, u, n, and m.

Ascender Loop Drill

- **How to create:** Starting at the baseline, create a small entrance stroke up to the x-height, make a short loop up toward the ascender line, then pull your pen back down to the baseline.
- **Stroke importance:** Many lowercase letters, such as b, d, h, l, and k have this stroke.

Descender Loop Drill

- **How to create:** This stroke is basically created in the opposite direction from the ascender loop. Start at the baseline, create an entrance stroke up to the x-height, pull your pen down to create a loop at the descender line, then bring it back up past the baseline.
- **Stroke importance:** This stroke is in many different lowercase letters, especially those with descenders, such as j, g, p, and y.

Oval Drill

- **How to create:** Start at the x-height and bring your pen down to the left toward the baseline, then back up to create the closed oval around the x-height.
- **Stroke importance:** It is so important the ovals are an actual oval and not a circle. The oval is in many different letters and the more consistent you make them, the more cohesive your lettering styles will be.

Step 3: Create Letterforms

Once you feel more confident in creating consistent (or mostly consistent) upstrokes, downstrokes, loops, and diagonals, you're ready to start learning how to create letterforms. There are so many different lettering styles out there, but the basic styles are monoline script, faux calligraphy, brush calligraphy script, sans serif lettering, and serif lettering.

Now it's time to practice those letterforms! Grab your lettering tool of choice and some tracing paper, and decide which style you want to start with. If you are a newbie, definitely start with monoline script and work your way up. Use the traceables and fill pages with some super-fun letterforms. Note the lettering tools recommended to complete each style. Challenge yourself and have fun exploring new styles.

Hand Lettering for SELF-CARE

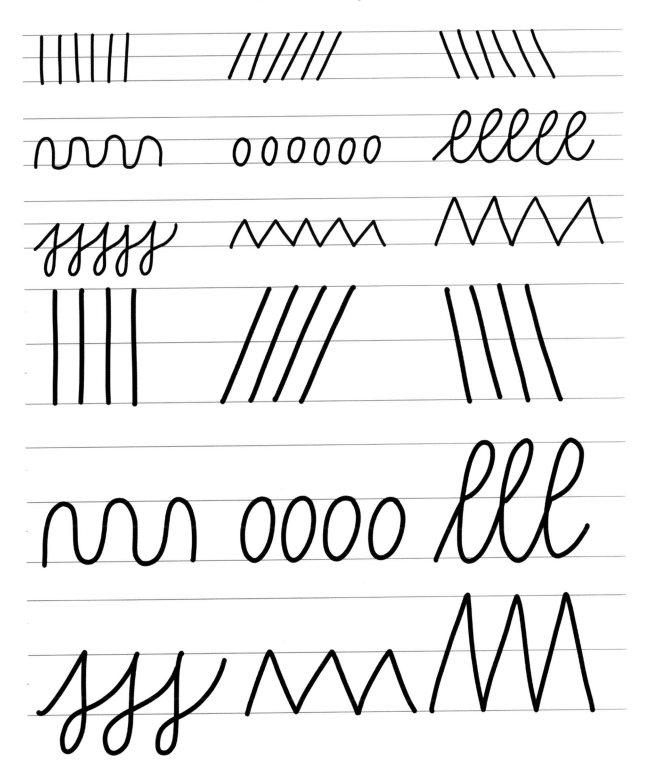

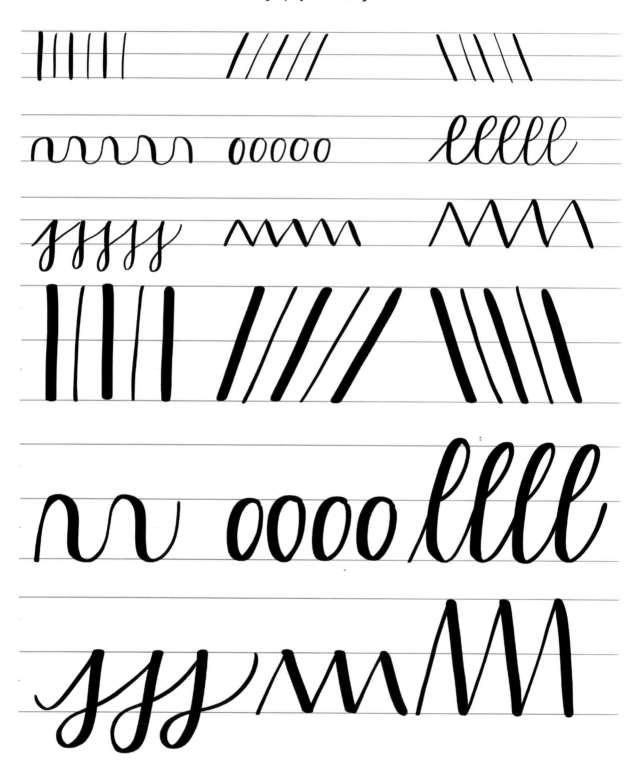

Hand Lettering for SELF-CARE

monoline script

Aa Bb Cc Dd

Ee Ff Gg Hh

Ii Jj Kk Ll

Mm Nn Oo Pp

Qq Rr Ss Tt Uu

Vv Ww Xx Yy Zz

faux calligraphy

Aa Bb Cc Dd

Ee Ff Gg Hh

Ii Jj Kk Ll

Mm Nn Oo Pp

Qq Rr Ss Tt Uu

Vv Ww Xx Yy Zz

brush calligraphy

Aa Bb Cc Dd

Ee Ff Gg Hh

Ii Jj Kk Ll

Mm Nn Oo Pp

Qq Rr Ss Tt Uu

Vv Ww Xx Yy Zz

SANS SERIF

A B C D E F G H I
J K L M N O P Q R
S T U V W X Y Z

SERIF

A B C D E F G H I
J K L M N O P Q R
S T U V W X Y Z

Hand Lettering for SELF-CARE

Monoline Lettering

A A a a B B b b C c c

Sans Serif & Serif

A A A B B B C C C

Small Brush Calligraphy

A A a a a B B b b C c c c

Monoline Lettering

A a a B b b C c c

Sans Serif & Serif

A A B B C C

Large Brush Calligraphy

A a a B b b C c c

DDdd EEee FFff

DDDD EEEE FFFF

DDdddd EEeee FFfff

Ddd Eee Fff

DD EE FF

Ddd Eee Fff

Gg Gg gg Hh Hh hh Ii Ii ii
GG GG HH HH HH II II II
Gg Gg ggg Hh Hh hhh Ii Ii iii

Ggg Hhh Iii

GG HH II

Ggg Hhh Iii

$Jj\,j\,j$ $KKkk$ $LLll$

$JJJJ$ $KKKK$ $LLLL$

$Jj\,jj$ $KKkkk$ $LLll$

$Jj\,j$ Kkk Lll

JJ KK LL

$Jj\,j$ Kkk Lll

HandLettering for SELF·CARE

M m m NNn n OO oo

MMMM NNNN OOOO

M mmm NNN nnn OO ooo

M m Nnn O oo

MM NN OO

Mm Nnn Ooo

Pp Pp QQqq RRrr

PPPP QQQQ RRRR

PPppp QQqqq RRrrr

Ppp Qqq Rrr

PP QQ RR

Ppp Qqq Rrr

SSss TTtt Uuu
SSSS TTTT UUUU
SSsss TTttt UUuuu
SSss Ttt Uuu
SS TT UU
SSss Ttt Uuu

Vv Vv Ww Ww Xx Xx

VV VV WW WW XX XX

Vv Vvv Ww Www Xx Xxx

Vv Vv Ww Xx Xx

VV VV WW WW XX XX

Vv Vv Ww Xx Xx

Yy yy Z yy & & & &

YYYY ZZZZ & & & &

YYyyy ZZyyy & & & & &

Yy Zy & &

YY ZZ & &

Yyy Zyy & & &

Once you have created letterforms in isolation, it will be time to start connecting letters. To ease the process of connecting letters, try to connect your letterforms as much as you can while practicing. This will make the process of connecting letters as easy as possible.

Step 4: Connect Letters to Form Words

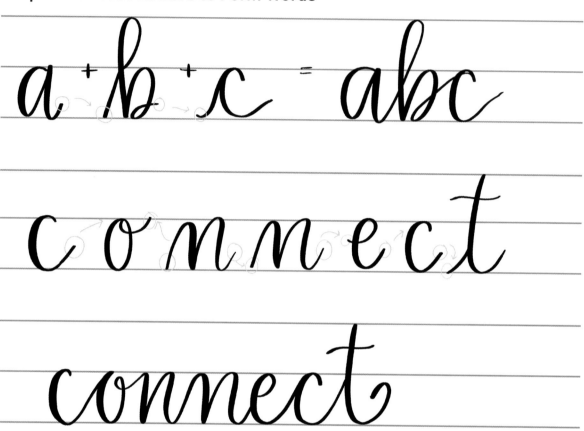

After learning how to create letterforms, the fun part of connecting letters to form words begins. Connecting letters takes a LOT of trial and error. This can definitely be an area of frustration if you don't keep an open mind and embrace that you will probably fail over and over again until you finally find what works for you. Make it a little bit like a game and try different combinations of letter connections.

When connecting letters, it's important to pay attention to the entrance and exit strokes of the letterforms you are connecting. Think about where your letter starts and where it ends to guide you in ending one letter and beginning another one.

Also, make sure to make the kerning, or spacing, between your letters as consistent as possible so that your letters have plenty of room to connect correctly. Again, this will take practice, but the more that you practice, the quicker your muscle memory will kick in.

Hand Lettering for SELF-CARE

Time to practice connecting those letters! All of the connections shown here are in monoline script so that you are only focused on the letter connections and not the pressure used with some tools, specifically brush pens. So grab a pencil, pen, or marker and some tracing paper and practice any or all of these letter connections.

Lettering Connections

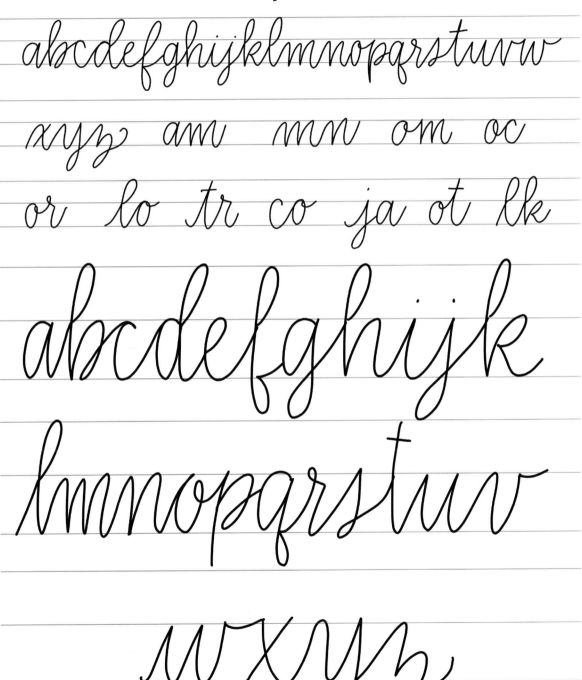

Now it's your turn! Have letters that you are trying to connect together? Use your tracing paper over these lines and practice connecting different letter combinations. Pay attention to those entrance and exit strokes, and watch your spacing.

Step 5: Compose Words to Create Phrases

Now it's time to put it all together! Let's be positive and compose phrases and quotes that make you smile a little more and worry a little less. Words are so powerful and can truly be a source of inspiration. Now you are ready to letter all that positivity and show yourself all that self-love through this new skill you have worked so hard to acquire. You did it!

There are just a few things to consider when you are composing words and phrases. First, make sure to pay attention to the layout of your paper. Especially at the beginning, it's a good idea to position your paper in the landscape layout, where the long side of the paper is horizontal. Doing this will give you lots of extra room to spread your words across the page, making it more likely for it all to fit.

Another thing to keep in mind is where the center of the paper falls, both horizontally and vertically, as you compose. Drawing in guidelines or using grid paper will help to keep your letter sizing consistent and to compose the words in an aesthetically pleasing way across the page.

Though you will definitely want to branch out and write your own words and phrases, tracing is always a good place to start! So (you know the drill by now) get that tracing paper ready and trace your worries away. Once you have traced the phrases and quotes, try writing them onto paper on your own. Make sure to grab the appropriate tool for each page and type of lettering.

Be happy, More coffee

Let yourself letter.

Choose joy, Smile more

Be happy, Smile

Let yourself

letter.

HandLettering for SELF-CARE

BE HAPPY BE HAPPY

LET YOURSELF LETTER.

LET YOURSELF LETTER.

CHOOSE JOY

CHOOSE JOY

SMILE SMILE

Be happy More coffee

Let yourself letter

Choose joy Smile more

Be happy

Choose joy

Smile more

Now it's your turn! Have phrases that you want to letter? Use your tracing paper over these lines and practice writing different words and phrases. Choose whichever tools you want. Again, pay attention to how you connect your letters and the spacing of your composed phrases.

PRACTICE LETTERING BREAKS

You've learned and practiced, and now you are ready to do more than just trace! Here are some quick prompts to help you learn and improve as you move forward. An awesome way to kick off your lettering practice each day, they will fit effortlessly into your lettering routine.

Improve Pressure and Control with a Brush Pen

- ❏ Fill a page by writing a single letter or basic stroke over and over.
- ❏ Connect different letters together.
- ❏ Add space between letters and slow down your strokes to get a feel for where to let go and add pressure.

Improve Specific Letters

- ❏ Break down trouble letters and practice the strokes that make them up.
- ❏ Fill a page with a single repeated letter.
- ❏ Tweak a letter to make it work for you and practice the letter with the changes.

Perfect Your Lettering Style

- ❏ Write a quote every day.
- ❏ Add embellishments to your style, such as a simple flourish or change in how the letter is formed.
- ❏ Make up a new style and practice using it.

Now that you have learned how to letter and feel more comfortable with all of the tools and basic skills, it's time to dedicate time to practice and lettering just for YOU! There are so many different reasons to letter; I've got you covered for all of them. So sit back, grab your lettering supplies, settle into your routine, and allow yourself the self-care of lettering.

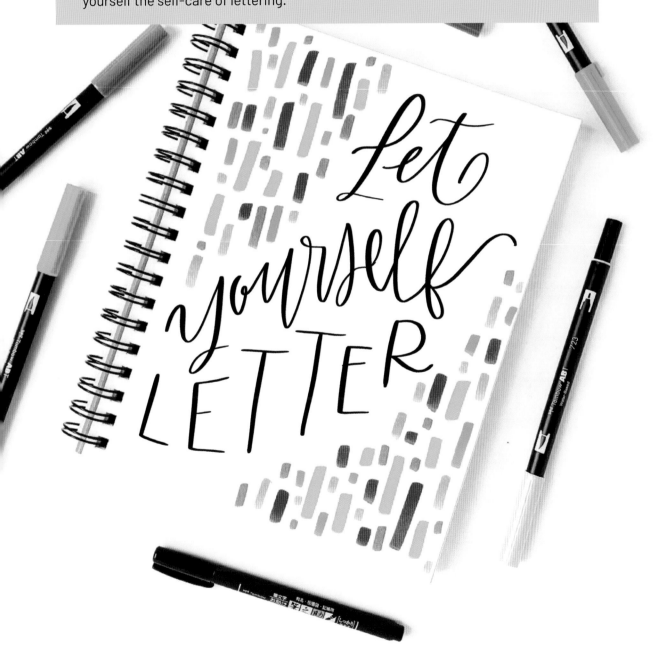

Chapter **3**

Let Yourself LETTER FOR FUN

You need a little more fun in your life. After all, fun and self-care definitely go hand in hand. When your day just needs a little jolt of happiness, try these fun styles, techniques, prompts, and projects. With that small dose of fun, creativity will soon follow!

PLAY WITH COLOR

Color makes everything more fun! Don't get me wrong, I love a quote written in beautiful and classic black ink, but adding a little color can really make a word or phrase pop.

ADD EMBELLISHMENTS

Adding a little flourish or doodle can make any lettering more fun. Be creative and try giving a little flair to your words.

MIX LETTERING STYLES

Lettering styles are made to be mixed! As you learn new styles, experiment and mix them together to add interest to your lettering.

LETTER ABOUT WHAT YOU LOVE

It may seem obvious, but when you do or focus on something you love, it is almost impossible not to have fun. So when you are eating your favorite donut or singing that song that pulls at your heart every time, draw some inspiration for your lettering.

LETTER WHILE YOU HAVE FUN

Yes, it's good to have a place to letter every day as a part of your routine; however, take your pen and notebook with you wherever you go. You never know when funspiration might hit! Whether you are having a blast on a nature hike or spending a weekend with your best friends, these experiences are more fun and well documented while you letter about them.

FUN LETTERING TECHNIQUES
Color Mix Faux Calligraphy

One of my favorite things to do is mix and play with colors while writing a fun phrase. This technique is super-simple while the result is bright, whimsical, and happy.

Materials You'll Need

- A pencil
- An eraser
- Paper or a sketchbook
- Three to five colored markers or pens in complementary shades

1. Grab your supplies. This technique looks great with a variety of different colors. I chose bright colors in this piece, but it would also look great with any single color or combination of rainbow colors. You can also use any kind of pen, but I love to create faux calligraphy with Tombow TwinTone Markers. They come in a variety of vibrant shades and have two different tips. When it comes to the pencil, any will work, but I prefer to grab a light sketching pencil that is easy to erase.

2. Sketch out your phrase lightly with a pencil. Can't think of what to write? No worries! You can totally use my go-to phrase. I have always loved writing "Choose Joy," and when I'm not

sure what to create, I often find myself trying to write these two words in a new way.

3. Alternating shades, cover each letter or part of a letter with a different color. Simply write over your pencil lines with the markers. Don't think too much about it, because you will be creating a faux calligraphy effect in just a little bit and will touch up all parts of your written phrase.

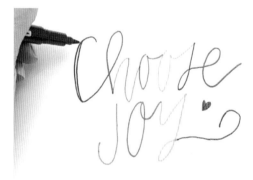

4. Create a faux calligraphy effect by drawing downstrokes in your letters. Downstrokes should be thicker than upstrokes. Simply draw in a line to thicken each downstroke until all of the word is done.

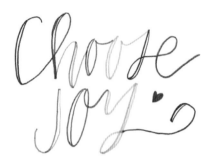

5. Go back and color in the downstrokes to make them solid, and use the tip of your markers to go over the phrase one more time, smoothing out the letters until you have a finished phrase. Gently erase any pencil lines.

LEFTY TIP

When coloring in faux calligraphy, especially with a colored marker, you may want to add the downstrokes by coloring in from right to left so that your hand doesn't go over any ink that is still drying.

Hand Lettering for SELF·CARE

Shadow Lettering

Some lettering techniques add a super-dynamic and bold look without much effort. I love to add all sorts of different shadowing to my lettering. Let's start with a simple shadow technique.

Materials You'll Need

- A large bright-colored brush pen or marker
- A small black brush pen or marker
- Paper or a sketchbook

1. Gather your materials. You can do a shadow technique with any kind of lettering style. In this tutorial I use brush lettering, but it could be used with faux calligraphy or even a sans serif style. Pick a style you are comfortable with and a marker that will create it. I love to use Tombow Dual Brush Pens for the shadow effect, because the bright colors and thick downstrokes make it easy to add a shadow. Then grab a smaller brush pen, like the Tombow Fudenosuke Brush Pen, to create the shadow effect.

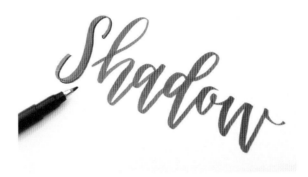

3. Draw in a shadow on the right side of the letters. Imagine that a light is shining from the left side of the paper, therefore casting shadows on the right side of your letters. Create a consistent shadow on the right sides and bottoms of the letters.

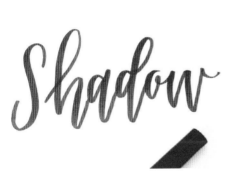

2. Letter a word or phrase in bold lettering.

4. Fill in any blank spots and make the letters look consistent.

Color Blending

Colors add so much to a piece of lettering. This technique demonstrates how to blend different colors together using several different methods. Blending water-based pens is so easy, and there are several ways to go about it, but it is also super-fun!

Materials You'll Need

- Water-based markers (like Tombow Dual Brush Pens). Make sure to have a darker color with several lighter colors that will go well with it.

- Blending palette (or piece of plastic or laminated paper)
- Mixed media paper (or thick, smooth paper)

- Optional: a mist spray bottle to spray the palette or blender pen

1. Color the darker colors on your blending palette.

Optional: For a watercolor effect, spritz some water on the palette after coloring on it with the markers.

2. Pick up your lightest color and color it on the darker colors to pick them up off of the palette.

Since the markers are water-based, the tip will pick up the darker colors to create a blended effect.

3. Write with the pen on the mixed media paper. Repeat steps 1 and 2 as needed until you have a complete word showing the colors from your palette.

Hand Lettering for SELF·CARE

4. To add more color to the word, pick up more colors with your blender pen and blend it onto the letters wherever you desire to add the color. Repeat as much as needed until you are happy with your blended word.

Note: If you don't have a blending palette, don't fret! You can take the tip of the darker color and color it onto the tip of the lighter color marker. Then write on the paper and see the same kind of blending. The tips are self-cleaning and blending the coloring on the tips will not hurt your pens. Just make sure to color out any excess color before storing your markers.

Word Mosaics

It's so important to create and be inspired by things that you love. Word mosaics are a fabulous way to tie your lettering to a concrete shape or idea. Fitting your words within a sketched shape and will add a whole new layer of fun to the piece.

Materials You'll Need

- A pencil and eraser

- Any paper (I used HP Premium Inkjet Paper)

- Any marker, pen, or brush pen (I used Tombow Fudenosuke Hard Tip Brush Pen)

1. Using the pencil, sketch out a simple or meaningful shape onto the paper. Feel free to erase and sketch again as much as needed.

3. Trace over your pencil lettering with your pen, marker, or brush pen.

2. Fill in the sketched shape with pencil lettering of any quote or phrase. Make sure to fill the entire shape with your design.

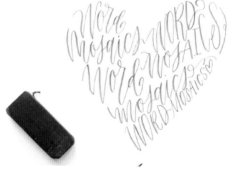

4. Erase your pencil marks, and you are left with a cool, new piece of art.

Hand Lettering for SELF-CARE

Patterned Letters

Sometimes your lettering just needs a little more detail, and patterns are a great way to add it. There is no one way to create patterned lettering. Just think of a fun idea and go with it!

Materials You'll Need

- Pencil and eraser
- Mixed media paper (or thick, smooth paper)
- Colored markers (if able, start with a super-light gray)
- Drawing pen

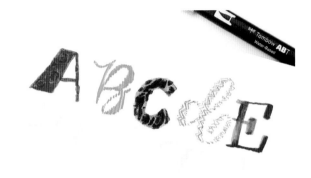

1. Start by sketching out whatever letters or words that you want on the page with your pencil. Feel free to erase when you make mistakes.

3. Draw in your pattern with darker or brighter colors. It can really be any pattern: cheetah print, gingham, polka dot, and the list goes on. Be creative and have fun filling it in.

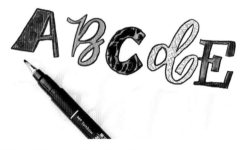

2. Cover or fill your sketch with a super-light color. Erase your pencil marks.

4. To add more detail and contrast to your design, trace the patterns with a darker color drawing pen.

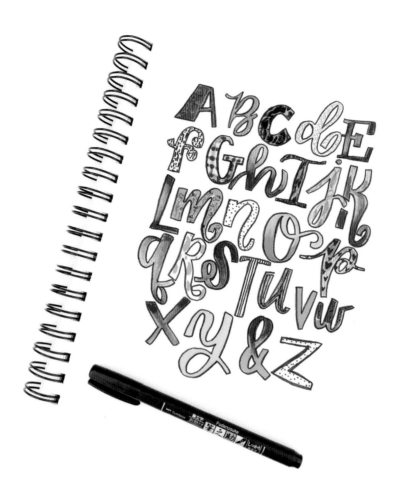

LEFTY TIP

When adding layers of ink to this piece, your hand may have a tendency to pick up wet ink. To prevent this, work right to left to fill in your designs. Make sure each layer is dry before starting a new layer on your patterned letters.

Hand Lettering for SELF-CARE

FUN LETTERING STYLES

Want to learn a few new lettering styles? Get inspired and feel free to grab some tracing paper to try out these super fun styles.

A B C D E F G H
I J K L M N O P
Q R S T U V W X
Y & Z

Aa Bb Cc Dd Ee
Ff Gg Hh Ii Jj
Kk Ll Mm Nn Oo
Pp Qq Rr Ss Tt
Uu Vv Ww Xx Yy
& Zz

FUN LETTERING QUOTES TO TRACE

Sometimes it's enjoyable to just trace letters and words. Have a little fun with your tracing paper and pen or marker of your choice.

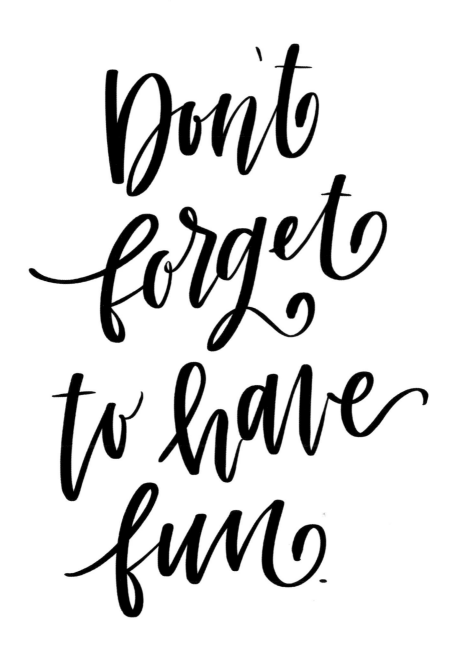

LAUGH
more

dance
OFTEN

CREATE

sing Loud

daydream

EAT
more
DONUTS

SMILE

HA HA HA! DREAM

You ♡ Love ya,
have friend.

a 🍕 pizza Take a
RISK

my Do More
of what
heart ♡ you LOVE

enthusiasm ENJOY

CHILLAX

be happy

positivity

BE MORE
awesome

FILL
your
CUP

HandLettering for SELF-CARE

FUN LETTERING BREAKS

The fun doesn't stop here! When you are in the mood to letter just for fun, there are so many different things you can do. If you need a little funspiration, these prompts will be just the ticket.

❏ Letter funny quotes as you watch a movie or TV show that you love.

❏ Keep a journal of funny things people you love say. Letter each quote in a different style.

❏ Letter your name in the same style over and over, but mix up the colors.

❏ Create notes for people you love and stick them in their bag or with their lunch. Make sure to make the theme of the notes super-fun.

❏ Go through the alphabet and fill a page writing funny words beginning with each letter.

❏ Create a fun patterned letter for a word or short phrase.

❏ Sketch a shape and create a word mosaic inside.

❏ Write out song lyrics as you jam to your favorite song.

❏ Write a simple word or phrase in black ink and add a colored shadow to it.

❏ Create a brand-new lettering style all your own, then use it to design a positive quote.

Chapter 4

Let Yourself Letter
FOR ENCOURAGEMENT

Feeling down? Need a little inspiration or positivity to lift up your day? Let yourself letter to give yourself that little boost of confidence that you're craving. Life can be tough sometimes, and the challenges it brings can feel a bit overwhelming. Make sure to take care of yourself and carve out a little time for self-love. An encouraging word can definitely go a long way.

SHOW SELF-LOVE

When you are lettering for self-care, it really does matter how you treat yourself. Make sure to be kind to yourself throughout the entire process of learning and practicing your new hobby. Use tools that you feel good using and create things that make you feel good about yourself.

KEEP IT POSITIVE

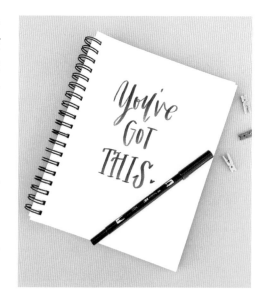

Words are so impactful on our mindset and attitude. Try to keep it positive while you are lettering. Doing this will make your experience a happy one and help the inspiration keep flowing. The positivity you create through your work will be contagious and flow into other parts of your life.

USE COMFORTABLE STYLES AND TOOLS

While it is definitely important to push yourself out of your comfort zone, sometimes it's beneficial to stay where you feel good and encouraged to keep going. When you are feeling overwhelmed or frustrated, make sure to take a step back and do something that you know works for you. For example, if you are getting overwhelmed trying to use a large brush pen, let yourself go back to a simpler tool or style such as a small brush pen or a regular marker for faux calligraphy. Do what is comfortable for you so that you feel encouraged and are able to truly focus on self-care.

LETTER GRATITUDE

In today's world it is definitely easy to get caught up in the little and big things that pop up and go wrong. When you are lettering, make sure to focus on what you are grateful for. Let gratitude seep through your work. Rather than feeling discouraged by what life throws your way or letting comparison get the best of you, focus on yourself and what you *do* have to smile about.

SURROUND YOURSELF WITH INSPIRATION

Something about surrounding yourself with the things that you love really gets inspiration going. Need some encouragement? Look no further! Turn on your favorite music, grab a donut, or take a lettering break using your favorite color markers. Surround yourself with all those things that make you smile and then let yourself letter. That happy feeling will definitely trickle into your work and leave you feeling encouraged.

ENCOURAGING LETTERING TECHNIQUES

Create a Positive Quote Composition

A positive quote can be an awesome source of encouragement and inspiration. Creating a simple quote composition isn't as hard as it looks. Use these steps to write out your own inspirational words.

Materials You'll Need

- Pencil and eraser
- Scrap paper, grid paper, and ink jet paper
- Pen or lettering tool of choice (I used a small brush pen)

if your design is consistently spaced out on the page. If your design is centered, there will be the same amount of squares outside of the sketch on the top and bottom as well as the two sides.

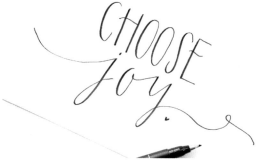

1. Start by dreaming up a simple quote or word to write out. Grab a sheet of scrap paper and create some sample thumbnails by drawing several small rectangles to represent the layout of your paper. Use a pencil to sketch out different design options for your word or quote. Try mixing up the spacing or style to give yourself different options. Pick your favorite design to turn into your final piece.

Note: When you are designing a quote com-position, it is easier to turn your paper to the landscape position (horizontally) rather than portrait. This allows you more space to spread your words across the page and makes it easier to fit longer words and phrases.

3. After your design is finalized you are ready to do your final copy. Use a pen or lettering tool of your choice to either go over the sketched design on the grid paper or complete the finished design on a final clean sheet of paper. Use the sketch as a guide to create your final piece. Don't worry if you need to write your final design in pencil first before going over it. Writing out quotes definitely takes practice.

4. There you have it! Your final quote. Put it in a frame or hang it as a positive reminder some-where that will bring you encouragement.

2. Once you have picked your favorite design, sketch it out on your grid paper. You can easily erase and redo as needed until you like the end result. Use the boxes in the grid to help figure out

Hand Lettering for SELF-CARE

Make a Lettering Style Your Own

We've all been there. You know, that place where you feel like no matter how hard you try, you will never be as good at something as everyone else. Lettering can be the same way sometimes. I remember trying to create letters the first time around, imitating someone else's style, and I was so frustrated. It was encouraging when I learned that I can make lettering my own thing by making a style all my own. If you find yourself discouraged or aren't loving a certain letter, make it your own with this fun exercise.

Materials You'll Need

- Two different colored writing tools
- Paper (grid paper works well, but any kind will do)

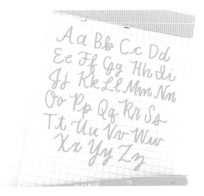

1. Start by using one of your colored writing tools (preferably the lighter color of the two) to write out whatever style you are either struggling with or are tired of and want to give a little face-lift.

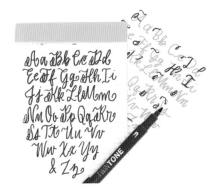

2. Next, use your other color to go through and edit the style. Look through each letter. See one that you don't like? Change it! Add a curlycue here or a creative crossbar there. Make the style

yours. To make your style consistent, try to add similar details where you can on your letters.

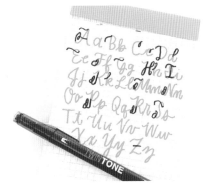

3. When you are finished, practice writing out the style and using it in your lettering work. Eventually, you will evolve a style all your own.

LEFTY TIP: It can be especially discouraging to try learning different lettering styles as a lefty. Whether you are following guidelines on a worksheet, in a book, or from an online or in-person workshop, be patient and figure out for yourself how to form your letters the way that works for you. You might start on a letter in a different place from what a guide sheet tells you to, and that is okay.

Bright Watercolor Encouragement Cards

Bright colors and happy words have a special way of lifting spirits. Make yourself or others little reminders by creating watercolor encouragement cards. These little pieces of paper have beautiful colors and words that are sure to make anyone smile. Add one to a gift or post it for yourself someplace you will see often in the day.

Materials You'll Need

- Water-based pens (Tombow Dual Brush Pens work well, but a watercolor palette will work too)

- A blending palette (or slick plastic surface to use as a palette)

- Watercolor paper cut into small cards (specific size doesn't matter)

- Water brush or watercolor brush with water

- A black marker or brush pen

1. Start by coloring the water-based pens onto your blending palette. Create a bright, encouraging, fun background by using your brush to pick up colors from the blending palette. The best part of this task is that there is no one way to create it. Do whatever you feel. I prefer leaving a little rough border of white around the edges.

2. Let the watercolor dry.

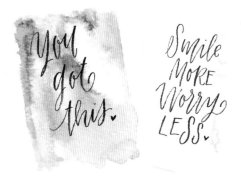

3. Use a black marker or brush pen to write an encouraging word or phrase on each card.

4. Post the cards wherever they might add a little encouragement to your day. The small size is perfect to post on a mirror or use as a bookmark. The options are endless.

Ways to Journal

Journaling is a great way to reflect and focus on your feelings and thoughts. The concept of journaling is very broad, and there are tons of different ways to journal. It's so important to take time to really focus on you…I mean you are lettering for self-care, after all.

Materials You'll Need

- A notebook or journal (anything you want to write in will work perfectly)
- Any writing tool that is comfortable to you

1. Turn to a clear page or page spread (two pages side by side).

2. Decide which way you would like to journal. There are *so many* ways to journal, including:

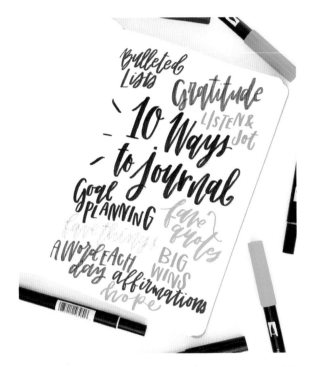

Bulleted Lists: Create fun bulleted lists of whatever is on your mind. Lists are repetitive and structured, but also broad, leaving lots of freedom to think and write. Whether you are listing places you want to visit or your favorite things said on a particular day, lists are a great way to quickly and concisely document thoughts.

Gratitude: Gratitude journaling is where you letter about what you are grateful for. When you focus on what you are fortunate to have, you definitely have a more positive perspective.

Listen and Jot: Whether it's listening to a podcast or your favorite song, writing what resonates with you is a great way to seek encouragement and inspiration.

Goal Planning: Goal-setting is so important. When you write a goal down and elaborate on a plan to achieve it, you are more likely to take it seriously.

Favorite Quotes: Words are powerful and meaningful, and writing them down is a great way to collect ideas and learn from others.

Favorite Things: Maybe you had the best donut of your life or had a blast watching your favorite movie with your family. Whatever you love, write about it.

Big Wins: Document any victories or memorable events that happen to you. It's important to take time to celebrate the good things.

A Word Each Day: Stumped on what to write about? Look through articles, books, or the dictionary for a new word to learn and write about.

Affirmations: Self-love is so important. Take time to write little affirmations, or notes to yourself. What do you need to hear? What do you strive to be? Write it down as if you believe it, and you soon will.

Hope: What do you hope for and dream of? Write it all down.

3. Complete the entry however you wish to. Use whatever lettering style or colors that you would like. You may use the same routine every day that you journal or mix up what you do daily.

4. Take time to look back at your journal entries for both encouragement and inspiration for what to create next.

TRACK YOUR PROGRESS

As you learn and progress in the skill of lettering, it is important to keep tabs on your progress. It can get easy to look at other people's lettering or get a new tool that is hard to use and be left with a feeling of discouragement. Keeping your work handy, whether it is in a sketchbook or in a journal, can allow you to see what progress you have made. When you need a good boost of encouragement and confidence, dedicate time to pull out some of your first lettering pieces and compare them to what you are able to do now. You will be amazed at your progress.

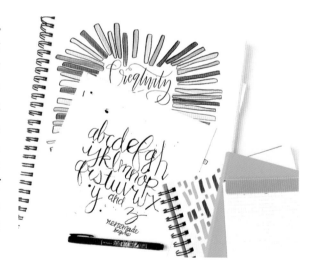

ENCOURAGING LETTERING STYLES

Need a little encouragement through a new lettering style? These two styles are simple and encourage creativity. Grab that tracing paper and try them for yourself!

ABCDEFGHI
JKLMNOPQR
STUVWXYZ

ABCDEFGHI
JKLMNOPQR
STUVWXYZ

a b c d e

f g h i j

k k l m m n o p

q r s t u v

w x y & z

ENCOURAGING QUOTES TO TRACE

Create some encouraging lettering, without feeling too much pressure. Trace these words and phrases using your tracing paper and writing utensil of choice, and help yourself feel encouraged.

I can do HARD things!

I am

kind · ENOUGH

brave

AWESOME

hopeful · WISE

HAPPY · me

Shine Bright

You are on a roll!

keep going

BE RESILIENT

Go you!

YOU ROCK

GET WELL
You are Amazing

You are STRONGER than you think.

It won't be easy but it will be worth it.

Go for it.

You've got this!

& DREAM big

ENCOURAGING LETTERING BREAKS

Everyone needs a little encouragement every now and then. Take some time to letter your own encouragement through these simple prompts:

- ☐ Write an encouraging note to yourself using some fun lettering styles.
- ☐ List 10 affirmations about yourself. What 10 things are most amazing about you?
- ☐ Create a gratitude journal entry about the parts of the day or week that you are most grateful for.
- ☐ Create a new lettering style and use it to write out a positive quote.
- ☐ Find a new podcast to listen to and letter something encouraging that you hear.
- ☐ Make encouragement cards to help get through your goals for the week.
- ☐ Write an encouraging phrase or quote for each day of the week. Collect them on the same page of a journal to review and draw inspiration from each day.
- ☐ Pull out your best lettering piece yet and make another version that is different using tools or skills that you feel confident in.
- ☐ Cover an entire sketchbook page with only positive or encouraging words. Make each word in a different style or color.

Let Yourself
LETTER TO RELAX

Life can be busy, and sometimes it can feel like you make it through an entire day without sitting down or taking a deep breath. It's so important to take the time to relax, and some days, that is exactly what you will need to focus on while you letter. So put on those comfy slippers and turn on some peaceful music, or whatever gets you in that relaxing zone, and let your pen do the rest!

LETTER WITH COOL COLORS

Cool colors can be soothing. If you are trying to relax, cool colors like blue, green, or purple can be very calming. There is definitely a time for bold and bright, but if you want to feel more chill, a cool color palette is going to be very helpful.

AMBIANCE IS EVERYTHING

Many times, our feelings and perspective have a lot to do with the environment that surrounds us. If relaxation is what you need, make sure to letter in a place that makes you feel calm, cool, and collected. Music, candles, and comforts such as a snack, cup of coffee, or fluffy blanket can definitely help you clear your mind and feel more relaxed.

USE FLOWY LETTERING STYLES AND ADD SPACE

Flowy lettering styles are so relaxing and satisfying. Try adding space in between your letters to make them flow. A little bit of space slows down your lettering and gives you time to really think about every

Let yourself rest.

stroke. You aren't in a rush. When it comes to lettering, remember that slow is fast. Taking your time and taking it stroke by stroke will not only improve the quality of your work but also be more relaxing. So do your best to take your time.

ADD IN TINY, REPETITIVE DETAILS

Sometimes it's nice to do the same thing over and over again. Filling a page with a single letter or lettering drill over and over can definitely be relaxing. Adding the same doodle to create a pattern all around a word is also a great way to add detail. Since it is repeating the same idea over and over, it feels simple and doesn't take a lot of thought, but is at the same time very satisfying and relaxing.

USE LETTERING AS MINDFULNESS

Lettering is a fabulous way to practice mindfulness and self-care. It's important to be mindful of your feelings, emotions, worries, and priorities. Dedicating just a little bit of time to letter just because is a great way to relax and recharge.

RELAXING LETTERING TECHNIQUES

Bounce Lettering

Bounce lettering is a fun way to add space and whimsy to your lettering. Since the lettering technically bounces around the baseline, it doesn't have to be perfect and flows around the page. While bounce lettering does take practice, it is a super-fun, stress-free way to write.

Materials You'll Need

- A pencil and eraser
- Paper (any paper will do)

- A straightedge

- Any writing tool you are comfortable with

1. Start by lightly sketching guidelines with your pencil and straightedge on a piece of paper. I draw a baseline, x-height, and ascender line. You could also draw a descender line, if needed.

Hand Lettering for SELF-CARE

2. Also with your pencil, start sketching a word or phrase. Rather than writing the word or phrase straight across the baseline, start with your first letter on the baseline, then let your pencil float up a little above or below the baseline. Add as much or as little space between the letters as you want, just make sure to be consistent, however you do it. Alternate between the baseline, above, or below it until your word is complete.

4. Once you are happy with your word, use your other writing tool to trace over your lettering. Then erase the guidelines and sketch, and voila. You will be a bounce lettering expert in no time.

Note: Eventually writing in this way becomes much more simple, and you won't need the guidelines. But the guidelines are a great way to get familiar with how to bounce your lettering.

3. Make sure that your lettering looks balanced, meaning that there isn't a majority of letters all in one direction or one that is in a different place. Use your eraser to make your lettering look consistent and bounce like you'd like it to. There isn't one way to do this, so make sure not to be too critical of yourself. You got this.

Watercolor Calligraphy

Something about watercolor is incredibly soothing and relaxing. Water-based pens are the best for this reason. When you place water on anything you've written or drawn with the pens, they work their watercolor magic, and there is truly nothing like it.

Materials You'll Need

- Water-based pens (Tombow Dual Brush Pens are great for this)
- Thick paper (watercolor paper or mixed media paper work great)
- A water brush or a watercolor brush

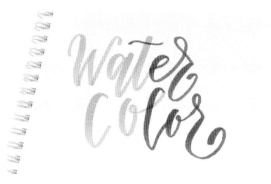

1. Start by selecting a fun combination of water-based pens. I chose different shades of pink and red, but tons of color combos would work great also.

3. Add some details with at least one additional color.

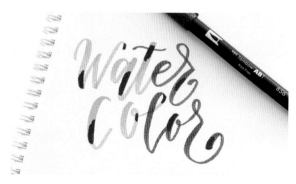

2. Using the pens, write out a word or phrase on the paper with a few colors.

4. Use the water brush to add water to the lettering. Carefully and slowly guide the brush over the lettering, keeping the colors inside of the lettering. Move the colors with the brush and see how the marker ink turns to watercolor and blends.

5. Once you are happy with the watercolor effect, make sure to let it dry flat.

Hand Lettering for SELF-CARE

Ombré Lettering

Blending colors can be super-soothing, especially when creating a monochromatic ombré effect. Monochromatic means that you are using different shades of the same color. For a relaxing effect, stick with cool colors like green, blue, or purple.

Materials You'll Need

- Water-based pens in at least three different shades of the same color (Tombow Dual Brush Pens work great for this)

- Thick paper (mixed media paper works well)

1. Start by writing a word or phrase on the paper with the lightest shade of water-based pen.

3. At the very bottom of the letter, layer just a little bit of the darkest color.

2. Leaving the top of the letter light with the first color, add the next darker shade to the middle and bottom of the letter.

4. Blend the colors together using the lightest shade that you have. I like to blend the middle with the top of the letter by pulling the middle color up. Then I do the same thing by starting at the bottom and going to the middle. This creates a nice ombré effect.

Relaxing Lettering Drills

Lettering drills are a great way to letter in a repetitive way without tons of effort or concern. At the same time, doing any kind of letterform drill will also build muscle memory while being super-relaxing.

Materials You'll Need:

- Any lettering tool you want to practice with (small brush pens are my favorite to use with drills)
- Grid paper or paper with guidelines

1. Use your lettering tool of choice to create unique lettering drills like the following:

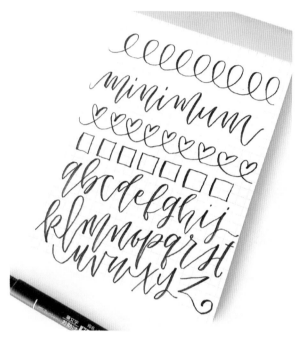

- **Loops.** Practice mastering the degree of pressure and the process of adding them gradually in the progression of a letter.
- **Minimum.** The word "minimum" is terrific to write out when warming up or practicing different styles.
- **Connected Hearts.** Connecting a shape, such as a heart, is a great exercise in using pressure to create consistent shapes over and over, which hopefully leads to forming letterforms the same way.
- **Boxes.** Boxes are another wonderful shape to practice utilizing pressure and manipulating a brush pen.
- **A Bouncy Alphabet.** Simply writing the alphabet in a fun, bouncy style is a fantastic way to practice letterforms and discover new ways of writing your letters.
- **Traditional Lettering Drills (Basic Strokes).** These drills are great to revisit anytime you need specific practice for a certain skill or letter.

2. Create your own drills! There are no specific rules. The idea is to practice so that you can use lettering tools comfortably, with consistent results from built muscle memory. Have fun with it!

ADD A DOODLE

Adding fun, simple doodles to your lettering can really give your work personality. Doodling the same little drawings over and over again around a word can be a very relaxing way to practice mindfulness. Create doodles that correlate with your feelings or just add fun little drawings just because.

Materials You'll Need

- Any combination of lettering tools
- Paper

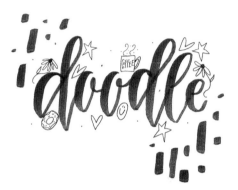

1. Start by writing out a word in whatever style you fancy.

2. Add doodles around the word. Sprinkle the doodles all around the page or completely surround the word with little drawings.

RELAXING LETTERING STYLES

It's time to relax. Flowy and bouncy lettering styles are not only pleasing to the eye but so relaxing to create. Try them out for yourself with your tracing paper and a pen or marker of your choice.

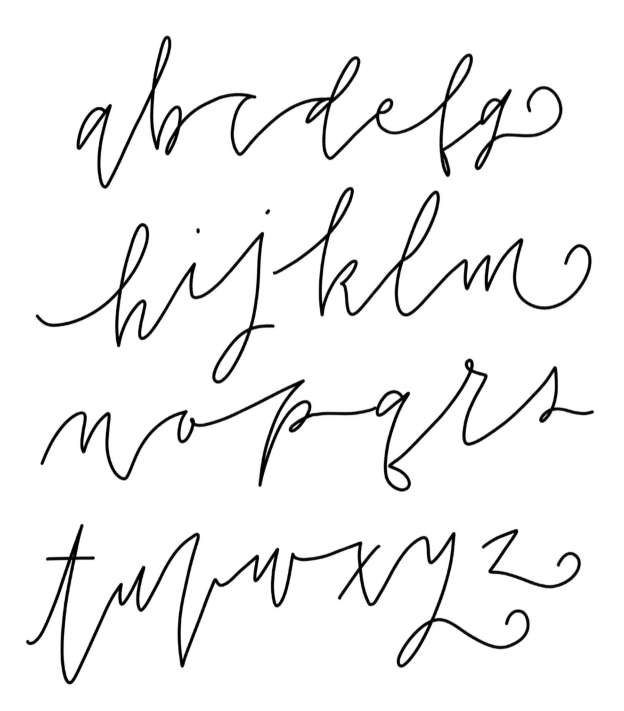

Hand Lettering for SELF-CARE

A B C D E F
G H I J K
L M N O P Q
R S T U V
W X Y & Z

RELAXING LETTERING QUOTES TO TRACE

Sit back, relax, and get ready to trace. Sometimes it's satisfying to trace and create happy words. Use tracing paper and your favorite lettering tool to trace these relaxing quotes.

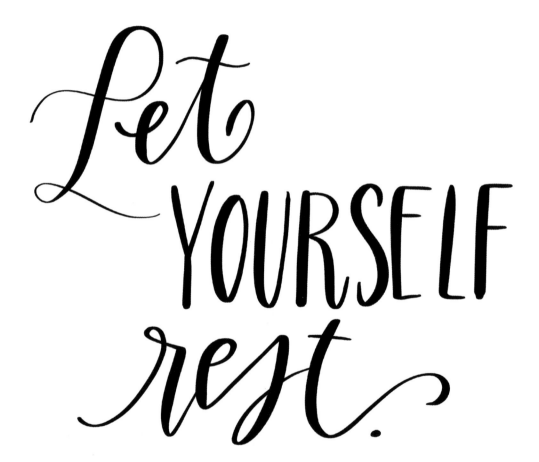

relax

dance your worries away

Take a BREAK

GET SOME fresh air

TAKE ME TO THE ocean

just breathe

Smile MORE. Worry LESS.

BE PATIENT

all i ♥

need is

a little

VITAMIN

sea

A Sunday
well spent
brings a
week of
content.

RECHARGE

take a
WALK

read more

Day dreamer

Breathe

ALL WHO wander ARE NOT lost,

GIRLS night out

be mindful - treat yourself

RELAXING LETTERING BREAKS

If you need a little extra boost of relaxation, follow these lettering break prompts. These activities are perfect for focusing your lettering on relaxation while getting a little practice in:

- ❏ Complete a relaxing watercolor quote using green, blue, and purple.

- ❏ Write "Just Breathe" in 10 different lettering styles and colors.

- ❏ Complete an entire page of lettering drills.

- ❏ Listen to your favorite playlist and letter random words that you hear.

- ❏ Write out different words in bounce lettering style, adding space between each letter so that the words flow.

- ❏ Letter a complete page of the alphabet repeated in different styles.

- ❏ Create a watercolor background and letter a word or your name on top of it.

- ❏ Write a word or phrase and surround it with simple, detailed doodles.

- ❏ Find multiple shades of a cool color (green, blue, or purple) and create an ombré lettered word or phrase.

- ❏ Go on a walk outside with a sketchbook and marker. Find a relaxing spot to sit and write what is on your mind.

Hand Lettering for SELF-CARE

Chapter **6**

Let Yourself Letter
TO CELEBRATE

Go ahead and let yourself celebrate the good things, big or small, that life brings your way. Don't let any victory pass you up without taking a little time to letter about it. When we celebrate the good things that happen to us, it's like giving ourselves a huge celebratory hug that not only makes us smile but also keeps us pushing forward.

CREATE LETTERING THAT STANDS OUT

Be bold with your lettering and celebrate what makes your style and craft special and unique. When starting a new skill, it's easy to want to be like everyone else, but if you stop paying attention to what others are doing and focus more on what makes your own lettering stand out, great things will happen.

CELEBRATE MISTAKES

Mistakes are inevitable, and they're the reason we have erasers. Mistakes are just proof that you tried and are going to keep trying until you get something that works. Rather than get defeated, celebrate mistakes. I have sketchbooks from the beginning of my lettering journey that are filled with messed-up lettering pieces of half-written quotes and spilled ink, but they are a beautiful reminder of where I started and how far I have come. It's impossible to find success without allowing yourself to make mistakes. Celebrate them, learn from them, and keep growing.

MAKE LITTLE VICTORIES A BIG DEAL

Learning lettering is definitely a challenging process, as is picking up any new skill. So make sure to celebrate any little victories that you experience. Maybe you find a new pen that you love or you are able to write in a style you've been wanting to learn forever. Take time to recognize this and reflect on it. No, I don't mean throw yourself a party, but maybe treat yourself to a break or start working on a special project using your new skill. Little victories like this are a big deal and celebrating them makes the process of learning lettering that much more fun.

FIND REASONS TO CELEBRATE EVERY DAY

I may sound like a broken record, but it always helps to find the silver lining in everyday situations. It's important to seek reasons to celebrate. Maybe it's the end of a Monday and you survived it with a smile; take time to celebrate with a lettering break or by doing something that incorporates lettering in a fun way. You can make signs or little banners, or create something that adds a little pizzazz to the day. Lettering in homage to the ordinary, normal things that everyday life brings can make them that much more fun.

INFUSE LETTERING IN LIFE'S BIG CELEBRATIONS

Push yourself to include lettering during huge milestone events. Whether it is creating decor or making a handwritten gift for someone, taking the time to celebrate using your lettering is definitely an exciting and significant part of lettering for self-care. So use some fun color and find reasons to celebrate big!

CELEBRATORY LETTERING TECHNIQUES

Confetti Lettering

Life is more fun with a little confetti thrown in. This lettering technique takes an ordinary, simple lettered word and throws confetti all around it using an effect called stippling. This lettering style is great for an envelope or celebratory quote.

Materials You'll Need

- A black marker or pen
- Paper of choice
- Colored markers or pens (the more colors the better)

1. Write out a word or phrase with your black marker on your paper of choice. Make sure that it looks bold. This technique works well written in any style.

2. Take a colored pen and create dots of different sizes around the outside of the word. Closer to the word make them more concentrated, but

moving to the outside of the word, make the dots a bit more spread out. This effect will look like confetti.

3. Complete this effect with each color until all the colors are incorporated and the word is covered with confetti.

Hand Lettering for SELF-CARE

Tie-Dye Lettering

Few things look brighter or happier than swirled colors in a tie-dyed shirt. You can easily carry over this effect into a lettering technique. Add a little tie dye to your letters with some simple steps and a bit of water.

Materials You'll Need

- Water-based pens (bright colors and a lighter color, like gray)
- Watercolor paper (mixed media paper can work too)
- Water brush (or watercolor brush)
- A black permanent marker or pen

3. Use your water brush (or watercolor brush) to move water around over the lettering, making the colors move and blend together. Continue doing this until all of the colors have come in contact with water.

4. Let it lay flat to dry.

1. Start by writing out your desired word or phrase on the watercolor paper using a light colored or gray water-based pen.

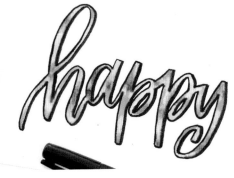

5. Use your black marker or pen to outline the lettering.

2. Layer on different colors over the gray lettering. Alternate all colors until the word is covered. Don't worry if there is white space in between, this will make the letters look more like tie dye when you add water.

Borders & Banners

Borders and banners are fun little illustrations that can be added to a card, planner, or even a big sign. Adding little details like these make any lettering piece a little more fun.

Materials You'll Need

- Any paper
- Any pen or marker

1. Plan out whatever lettering piece you fancy. Decide where you can add a border or banner to embellish it.

2. Add a border or banner of your choice.

Border. Little dots or mini lines written around the edge of a design can add a lot of interest to a piece. However, the sky is the limit. You can easily come up with your own creative border.

Banner. Banners are simple to draw, whether it is a simple ribbon banner or a more complex banner (see the steps pictured). Start simple and let yourself create banners of your own.

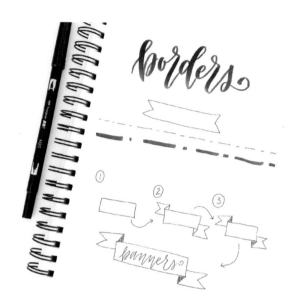

Negative Space Border

Creating a simple border by coloring in the negative space surrounding your piece can add interest to lettering, making it bolder and stand out in a whole new way.

Materials You'll Need

- Any paper
- One colored marker (I like to use both a fine-tip and a brush-tip marker during this technique, so Tombow Dual Brush Pens work great)

Hand Lettering for SELF-CARE

room to color in the negative space. A cloud or geometric shape work very well for this. Adding little lines or dots around the outside shape adds an element of whimsy to the piece.

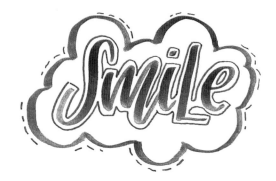

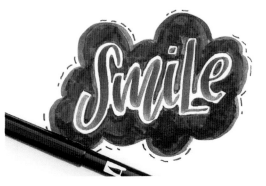

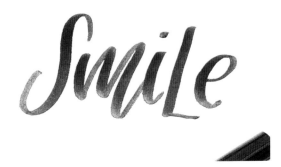

1. Begin by writing out a word or phrase in a bold style with your marker anywhere you'd like on your paper.

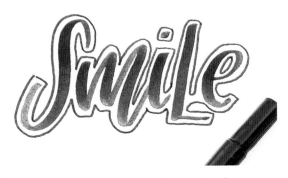

2. Use a fine-tip marker to outline the word, leaving a cushion of white space around the words. Completely surround the word with the outline.

4. Color in the negative space between the inside outline and the outside shape. Make sure to color in all of this space until there is no white left.

3. Add an enclosed shape to form a border around the outside space of the word, leaving

Rainbow Writing

Rainbows are happy little bursts of color, and it is such a delight to rainbow write. Alternating rainbow colors to create a word can really elevate a simply written word.

Materials You'll Need

- Any paper
- Pencil
- Markers in rainbow colors (small brush pens work great for this, but any pen or marker will do)

1. Start by sketching or planning out whatever you want to write with a pencil. Then, gather your rainbow colors for the lettering.

3. Thicken up your letters if needed, using the corresponding colors to make the lettering look finished.

2. Create a rainbow effect by writing each letter with a different color. Make sure to connect all of the letters so that they flow. This can be done in any style but looks very fun written in bounce lettering.

Hand Lettering for SELF-CARE

CELEBRATORY LETTERING STYLES

Celebrate with some fun new lettering styles! All you need is your favorite pen or marker and some tracing paper. Trace these new styles and try to make them your own.

A B C D E F
G H I J K
L M N O P Q
R S T U V W
X Y & Z

A B C D E
F G H I J
K L M N
O P Q R S
T U V W X Y Z

CELEBRATION LETTERING QUOTES TO TRACE

Time to celebrate with some festive words, phrases, and quotes. So throw some confetti and get ready to trace these fun, commemorative words!

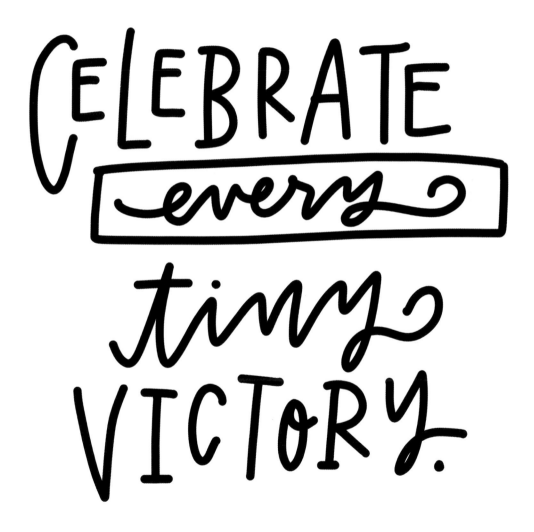

CELEBRATE every tiny VICTORY.

HOORAY ♡

enjoy the MOMENT

You did it!

celebrate every day

OH YAY! WOO HOO

YES

oh happy day

HAPPY
birthday Yippee

WE DID IT thank
you
so much

Where's the cake?

You did it!

AMAZING

CUE

So Proud

THE

awesome

Confetti

treat

yourself

ENJOY

CELEBRATORY LETTERING BREAKS

Add a little celebrating to your day with these fun celebratory lettering breaks. Use the prompts to document all the big and little wins of both your ordinary and extraordinary days.

- ❏ Make a list of tiny victories for the week in a journal or notebook.
- ❏ Create a hand-lettered banner to celebrate an everyday or special event.
- ❏ Letter a word or phrase on a wrapped gift.
- ❏ Create a card with a quote or word lettered using the confetti-lettering technique.
- ❏ Track the things you are grateful for throughout the day on a posted paper or chalkboard.
- ❏ Use tie dye lettering to write a word, quote, or phrase.
- ❏ Make little cards to label dishes or place settings at a get-together.
- ❏ Rainbow write a quote or phrase.
- ❏ Take pages that you made mistakes on. Color different parts of the page with different colors. Then, shred or cut the paper to make confetti.
- ❏ Start a journal where you add one positive event or quote from the day. Add each day's idea in a different lettering style.

Chapter 7

Let Yourself Letter FOR PRODUCTIVITY

For those times when you feel like you need to take a break but that to-do list is piling up, you don't have to completely throw your obligations out the window! Don't get me wrong, time for self-care is a must, but you can totally multitask and make some of those tasks a little more fun. Whether you are listening in on a conference call, trying to stay organized, or making a list for the grocery store, incorporating lettering is a great way to make tedious tasks more fun.

INFUSE LETTERING INTO WORK

Work doesn't necessarily have to always feel like work. Lettering is one of those golden skills that, once learned, can be used and incorporated into nearly any endeavor or experiences life throws your way. Find ways to infuse and include your lettering in your work, whether it's taking pretty notes in a meeting or using your new skills to create a sign or project.

KEEP LETTERING TOOLS HANDY

The brush pen and markers are magical tools that can create amazing artwork in fun colors and fit conveniently in your purse or work bag. Keeping those lettering tools handy can make it easy to use your new skill more often. Plus, life is just better with markers around, am I right? (Yes, I am.)

KEEP IT SIMPLE

Simple lettering styles like monoline script and sans serif are great for productivity. They are easy to read while being simple and quick to write. Keeping it simple can give you lots of opportunities to use lettering in the little everyday tasks that are just screaming for a little lettering action. That grocery list and planner don't know what's about to hit them.

LABEL EVERYTHING

Let's face it. Being organized is an important aspect of productivity. Lettering can come in handy when it comes to organization because those simple styles make great labels! Labeling everything is a great way to use lettering to be more productive.

TAKE NOTES (BECAUSE IT'S FUN)

I've always been a notetaker and self-proclaimed doodler. Not only does it make what I hear or learn visual, but it keeps me engaged in long meetings and makes monotonous tasks a little more fun. So break out that pen or marker and that super-cute notebook and take all the notes.

PRODUCTIVE LETTERING TECHNIQUES

Sketch Notes

What can be more fun than doodling and lettering everything that you hear or need to take notes on? Sketch notes are an easy and fun way to take notes while trying to be productive. There's no better way to infuse lettering into that long work meeting.

Materials You'll Need

- Any markers or pens

- Any paper (I prefer using a notebook together to keep my notes together and organized)

Directions

1. Start by writing a fun heading somewhere at the top or middle of your page spread.

2. Draw a shape or lines to divide the space or keep it wide open to fill with your lettering as you go.

3. Start taking notes on things you hear or ideas you have. Keep adding notes until the entire paper or page spread is filled. Add interest to your notes by adding pops of color, changing up lettering styles, and adding fun doodles and shapes. Remember there are no rules. Have fun and let your creativity take over!

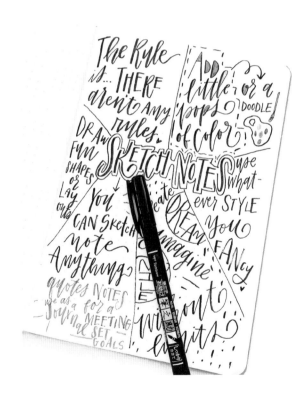

Lists Galore

Lists. We all make them and most of the time it's on that random receipt or the back of that envelope the bill came in yesterday. However, those lists can actually be a fun way to incorporate lettering into your every day.

Materials You'll Need

- A small notebook, pad of paper, or scrap paper
- Any pen or marker

There aren't really directions for creating a list—it's pretty self-explanatory. However, there are definitely ways to add a little pizzazz to your everyday lists.

Ways to Make Lists Fun

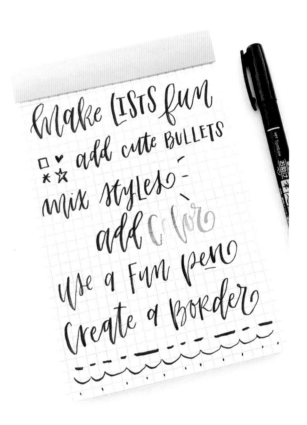

- Add cute bullets. Elevate those little dashes next to the items in your next to-do list. Draw little check boxes or a doodle such as a heart to elevate the level of fun in your productivity.

- Mix styles. Mixing lettering styles is a quick and easy way to make a list more interesting to write. I like to write my headings in a brush script and use a sans serif or block style under the headings. It makes it easier to organize a super-lengthy list.

- Add color. Add little pops of color to make your lists bright.

- Use a fun pen. Markers and pens make everything more fun.

- Create a border. Keep your list organized and make it a little more interesting with a simple border, such as dots, a scallop, or little dashy lines.

- So take care of business and have a blast while you're at it!

Hand Lettering for SELF-CARE

Hand-Lettered Address

Everyone loves a good piece of happy mail. Hand-lettered addresses might look a bit complicated, but they don't have to be. Follow some simple and straightforward steps to create your own hand-lettered envelope. Send that next note or bill payment with a little extra happy.

Materials You'll Need

- A pencil and eraser
- An envelope
- Straightedge
- Pen or marker of your choice

on the envelope. If needed, erase parts of the address and redo until you are satisfied with how it looks.

1. Using the pencil and eraser, sketch out a layout for your address. Addresses are normally four lines but can be more if there are additional names. Sketch guidelines for however many lines you need, using a straightedge, directly on the envelope. You may also find it helpful to draw in lines in the horizontal and vertical center of the envelope to pinpoint the middle.

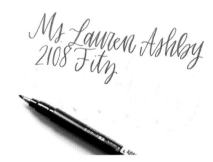

3. Trace over your address with any pen or marker you are comfortable using. Make sure to let the ink dry well.

2. Using whatever lettering style you desire, write in the address with a pencil, keeping it centered

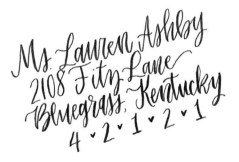

4. Erase all sketch marks and guidelines from the envelope. Yay! You are ready to send a happy note.

Bold Headings

Planners and calendars are wonderful places to use lettering to make certain events or ideas stand out. Easily transform a plain lettering style into a fun heading by adding just a few steps. Make that lettering BOLD.

Materials You'll Need

- Any lettering tools (markers tend to create bolder styles than pens)
- A calendar, planner, or any paper

1. Write a heading in the style of your choice.

2. Tweak your lettered heading by making one of these changes:

Thicken Letters: Take your lettering tool and go back over the lettering, thickening the strokes.

Draw a Border around Letters: Trace around the letters in a solid or dashed line.

Create a Shadow: Use a different colored marker to draw in a shadow surrounding the heading.

Layer Colors: Write over the lettering with a darker contrasting color.

Outline Letters: Draw a fine outline around the edges of each letter, using a contrasting color.

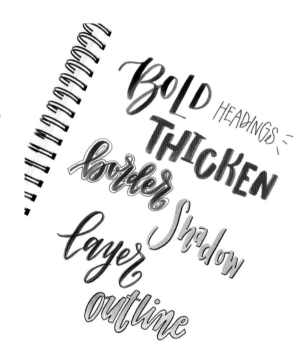

Hand Lettering for SELF-CARE

USE LETTERING EVERYWHERE

Yes, I mean *everywhere*. When taking on a new hobby, it can be easy to get started but even easier to run out of time for that new habit. If you use your lettering in multiple areas of your life, like at work or at home when you are completing every-day tasks, you will be able to not only practice your lettering but also focus on yourself in the process. Productivity isn't always fun, but you can make it that way by doing what you love at the same time.

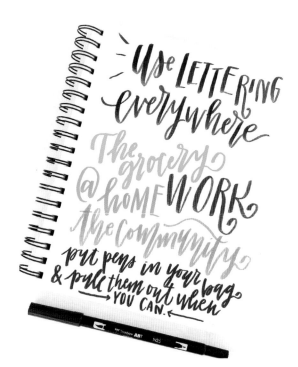

PRODUCTIVE LETTERING STYLES

Time to be productive with these simple lettering styles that are perfect for organization and planning. Trace these easy styles and get ready to be more productive while infusing a little creativity and fun into the mix.

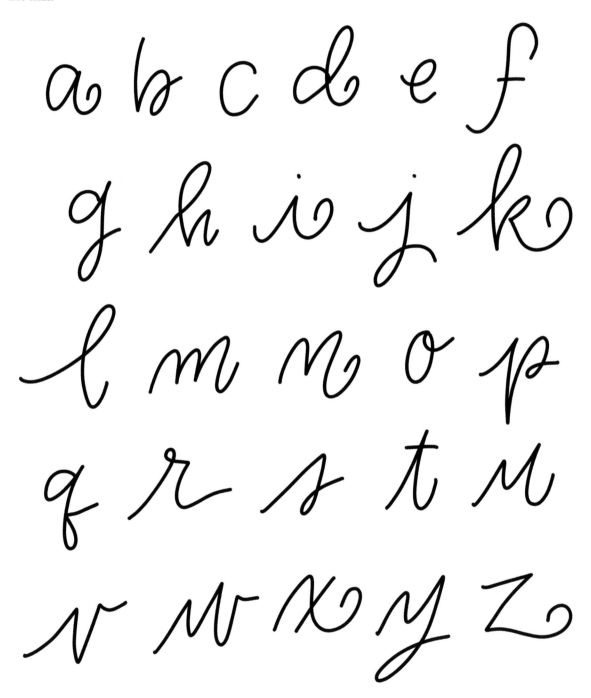

Hand Lettering for SELF-CARE

A B C D E
F G H I
J K L M N O
P Q R S T U
V W X Y & Z

PRODUCTIVE LETTERING QUOTES TO TRACE

Being productive doesn't have to be boring. Cross off those to-do lists while you have a little fun and get some lettering practice. Grab that tracing paper and your favorite pen or marker and get ready to trace some productive words and phrases.

Stay Consistent.

Hand Lettering for SELF-CARE

Plan for success

prioritize

what matters

goal getter

You

GO

believe

CAN &

you will

SAY YES

JUST START

Sunday

*
*

MONDAY

tuesday *

WEDNESDAY

thursday

Friday *

*SATURDAY

Just
follow
your
HEART

You
CAN
DO
It

TO DO:

You got it

To Do

A GOAL without a plan is JUST A WISH.

go = Make a list

to Go To do Go Do

But first coffee

Go groceries

PRODUCTIVE LETTERING BREAKS

Need a little push for productivity? These lettering prompts will help you stay productive while also getting your lettering practice in:

- ❏ Create labels for bins or storage items for a closet or cabinet.
- ❏ Use different lettering styles to add events to a calendar or planner.
- ❏ Listen to a podcast or meeting and create sketch notes of the major ideas.
- ❏ Letter a beautiful grocery list.
- ❏ Create a sketch note bucket list.
- ❏ Complete a task for work utilizing your lettering skills.
- ❏ Create a bullet journal using different lettering styles.
- ❏ Write down your goals using your favorite lettering tools.
- ❏ Practice writing the days of the week and months of the year in brush calligraphy.
- ❏ Productively make time for lettering. Set a timer for 30 minutes and strictly letter for that amount of time.

PART 3

Get excited! You have learned and practiced your new skill of hand lettering and now you get to add a little bit of creativity to the picture. Use your new hobby to create projects and share your lettering with others. Up to this point, you have traced, practiced, and built muscle memory and confidence. Now it's your turn to use lettering to create styles and projects all your own.

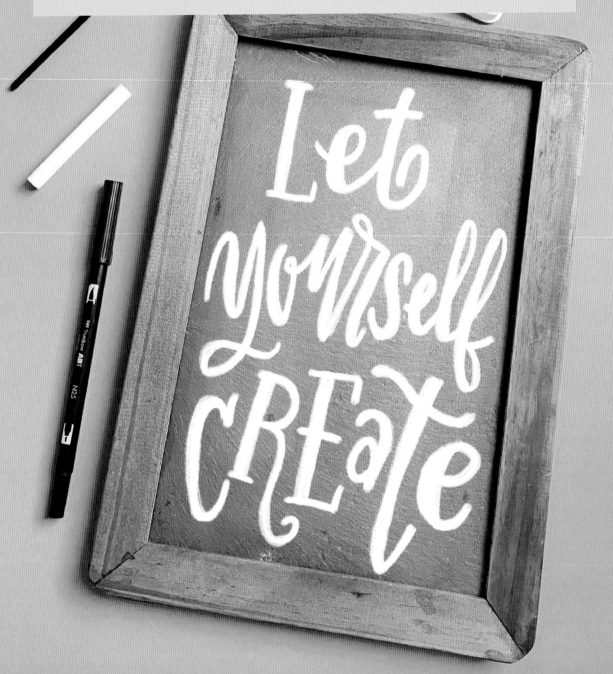

Chapter 8

From Letter TO PROJECT

Now that you have let yourself learn and letter, it's time to let yourself create. You have practiced so many different styles and techniques and are ready to use your own creativity to apply your lettering knowledge to projects of your own. Don't worry, though. I've got your back with some tips for different types of lettering projects. We'll just be scratching the surface here, but you'll have all you need to get started, including some creative project ideas. Let's get to making!

PROJECTS ON PAPER

You are probably thinking, "Well, we have been doing projects on paper through this entire book." While we have, it's important to consider how to create with paper and what tips and prep to keep in mind.

Creative Tools

You'll be able to create projects using tools that you have learned to use and feel comfortable with. Brush pens, markers, and pencils will probably entail the bulk of what you create with. Watercolor palettes are also great to add to your paper project toolbox along with tons of cute paper items that are screaming to be lettered on.

Prep

Prep for paper projects is pretty self-explanatory: always have scrap paper, a pencil, and an eraser handy. It's so important to sketch out your ideas before putting ink to paper.

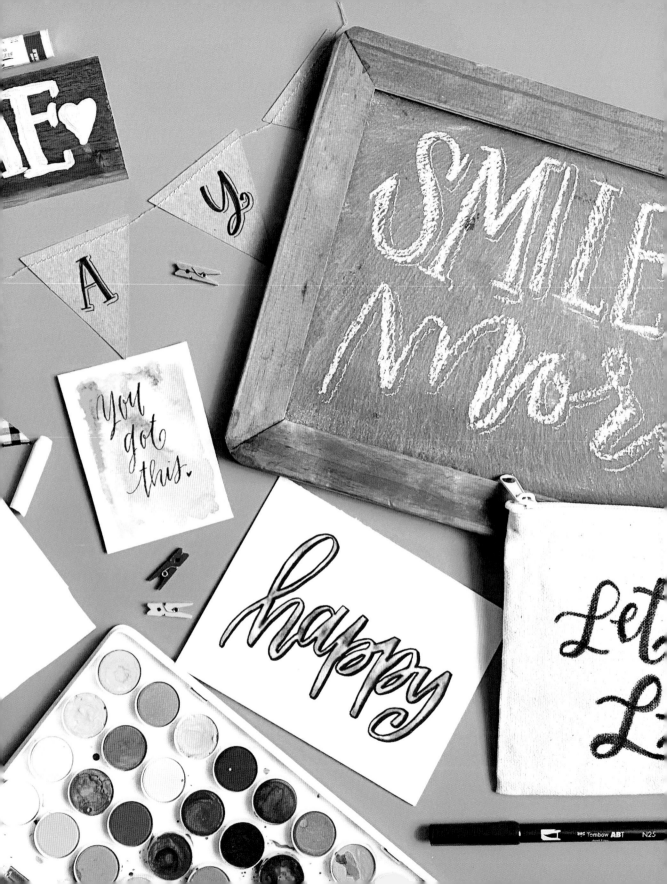

Tips

Before you pick up your pen or marker, test whatever you are writing on. You may choose to work on some projects using various types of paper or surfaces. Ink can absorb in different ways, depending on the surface. Make sure to get the right tools for the job.

Also, consider what your project will be used for and where it will be displayed. Some pen and marker inks can fade in light. Think carefully about what the best lettering tools will be for getting the job done.

Don't be afraid to create! Projects are open to interpretation and creativity, so don't be afraid to try new things while incorporating lettering styles and techniques that you are comfortable with. You've got this!

Paper Project Ideas

- Vision Board: gather pictures and sources of inspiration and attach them to a poster or piece of tag board along with hand-lettered words that represent your inspiration for goals, dreams, and your vision for the future.

- Framed Affirmations: It's important to remind yourself how awesome you are. Create a simple hand-lettered composition of some positive reminders for yourself. When you are finished, these will fit perfectly in a frame and serve as a self-care reminder.

- DIY Notepad: Want your own custom notepad? Easy peasy! Start by cutting paper all the same size and lettering whatever word or phrase you want to at the top of each page. Then use padding compound (order some online or pick it up at your nearest craft store) to attach all of the note pages together.

- Encouragement Cards: Letter little words of encouragement and positivity. These little cards can be of any material or size and are perfect to keep for yourself or give to someone else.

- Hand-Lettered Tablescape: Kraft paper makes a wonderful table covering. Letter a greeting, add a fun holiday doodle, or write out the names of your family members or dinner guests around the table. Whatever you choose, the lettered details on the tablescape will make it look personalized and special.

- Gratitude Journal: Create a gratitude journal documenting everything that you are grateful for. Take time to reflect on what you write down from time to time to keep everything in perspective.

- Hand-Lettered Gift Wrap: Grab some plain wrapping paper or kraft paper and a brush pen or permanent marker. Wrap your present and cover it with lettering. Write a personalized message or a holiday-themed quote or phrase.

- Gift Tags: Tags are a super-cute addition to any gift. A little hand-lettered detail makes a gift personal and thoughtful.

- Recipe Cards: Recipes are often personal and special. Create your own recipe cards by lettering the ingredients and directions in different, fun lettering styles.

Hand Lettering for SELF-CARE

- Happy Mail: Everyone loves a good piece of happy mail. Create your own cards or hand lettered envelopes to send to those you love.

PROJECTS ON FABRIC & CANVAS

It can be fun to branch out from lettering solely on paper. Fabric and canvas are fantastic media to try lettering on. Don't be scared to branch out. Pick up your paintbrush or pen, and let's get started.

Creative Tools

When it comes to lettering on fabric and canvas, you have the option of many different lettering and creative tools to use. Acrylic paint and oil-based paint pens are my favorites for lettering on fabric or canvas. Alcohol-based markers like the Tombow ABT PRO Alcohol-Based Markers are also great. You'll need a paintbrush to apply the acrylic paint, so make sure you have one handy. As far as the canvas and fabric for writing on are concerned, your local craft store is a terrific place to find them.

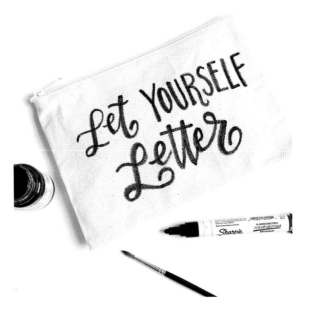

Prep

Make sure that you put plastic, wax paper, or something else that will not stick, on the opposite side of any fabric that you are going to paint or letter on, just in case the paint bleeds through.

If you are writing on fabric, iron it first so that the lettering can go on smoothly and not encounter any creases.

NOTE: Make sure to test whatever marker or paint you are going to use before starting your project. All fabrics and canvases are different, and while most paint and paint pens should get the job done, how well they do truly depends on the materials you will be working with.

Fabric And Canvas Project Ideas

- Hand-Lettered Jacket: Have an extra jean jacket that is screaming for some art on the back? Use acrylic paint to letter your very own denim jacket. Paint designs, add colors, and have fun!

- **Painted Pen Pouch:** Canvas fabric is stylish and easy to write on, especially with paint pens. Write your name or an important phrase on the front of the pouch.
- **Lettered Canvas Quote:** Canvases are so easy to find and come in all shapes and sizes. Paint pens and acrylic paint both work great on canvases, so grab the materials that you are more comfortable with and start creating.
- **Hand-Lettered Pillow Cover:** Pillows are a cute way to add personalization to your home. Add an inspiring quote or family name with acrylic paint or a paint pen of your choice.
- **Brush Calligraphy Table Runner:** Flowy fabric can be a bit tricky to write on but looks beautiful with lettering all over it. Pick a long piece of flowy, sheer fabric (make sure it has a smooth, dull texture for writing on). Alcohol-based markers work great for this project. Cover the fabric with quotes or words that are important to you and drape it as a table runner.

PROJECTS ON CHALKBOARDS, WOOD, & OTHER SMOOTH SURFACES

It is so much fun to create projects on chalkboards, wood, and other smooth surfaces. While these types of projects are pretty simple, make sure to take the time to prep for them so that none of your materials go to waste.

Creative Tools

Break out those chalkboards, wood blocks, and any other items that you want to write on. You'll want to grab a paint pen, acrylic paint, or permanent marker for most projects. Of course, for chalkboards, chalk, and chalk pencils will come in handy. You may also need something to gloss or seal the wood (like Mod Podge) so that it doesn't absorb too much paint or bleed and is more durable.

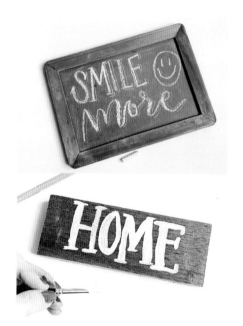

Hand Lettering for SELF-CARE

Prep

Different materials require a different kind of prep.

Chalkboards: Prep your chalkboard by seasoning it first. To do this, rub the side of a piece of chalk onto the board, covering it in chalk dust. Once it is covered, wipe it with a dry towel. This will protect the surface of your chalkboard so that what you write doesn't get burned into the surface and become impossible to remove.

Wood Blocks: Depending on the texture of your wood block, you may need to seal it or add a gloss to it so that it takes paint well. If you do add something to the surface, make sure that it consistently covers it and dries before you add your lettering.

Other Surfaces: Clean all other smooth surfaces like ceramic, acrylic, or plastic with a gentle cloth and soapy water. This will get any excess residue off so that it takes paint well.

Chalkboards, Wood, & Other Smooth-Surface Projects

- Chalkboard Quote: Create a cool chalkboard quote incorporating a quirky, fancy, or elegant style that you are comfortable with. Add some fun details, like a shadow, using a chalk pencil. The best part is once you get tired of your quote, you can wipe it off and try again.

- Hand-Lettered Wood Block: Use acrylic paint to letter an important word or quote on a wood block. You may want to sketch it out with a chalk pencil first to make sure that you can fit everything onto the piece of wood.

- Hand-Lettered Ornament: Ornaments come in so many different forms, such as acrylic, wood, glass, and plastic. Use acrylic paint or paint pens to design a one-of-a-kind ornament.

- Personalized Gift: Many items can be personalized before giving them as a gift. A paint pen is the perfect way to add a name to any smooth-surfaced gift.

- Lettered Balloon: Take a paint pen and write a word or phrase onto an already-inflated balloon. It will add a personal touch to any event or party.

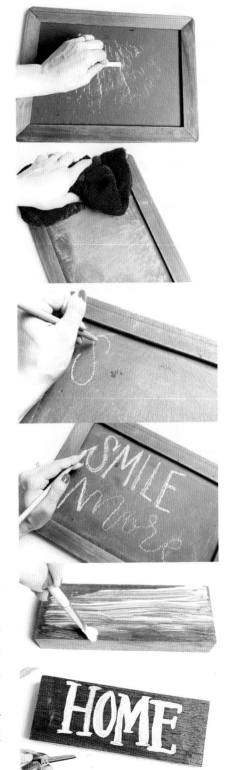

- Sketch out your designs with a pencil or chalk pencil so that you know where you will put each component of your design.

- Have a pencil sharpener handy so that you can sharpen your chalk pencils and chalk. Believe it or not, chalk works best when it is sharpened to a point.

- Be patient while figuring out what materials work well together. You can probably find something to write on most surfaces, but not all materials will work the same for every project, and that's part of the fun!

KEEP CREATING

Creating doesn't have to stop there. As you make new projects, try to keep tabs on what you enjoy and want to continue creating. If a project doesn't bring you joy, switch focus to a different one, keeping in mind that you are lettering for self-care and should enjoy what you are doing as you create.

With so many different project possibilities, there aren't enough pages in this book to list them all. Get inspired! The more you create, the more ideas and inspiration you will have.

Challenge Yourself & SHARE YOUR LETTERING

You've started lettering and creating with your lettering. I know what you are thinking: "What now?" It's not time to stop moving forward, but rather it's a wonderful time to continue challenging yourself. When I initially started learning lettering, I never dreamed that it would impact my world the way it did. My love for calligraphy and creating literally trickled to all areas of my life, making it much more enriched and better overall. So challenge yourself to keep moving forward with your lettering.

CHALLENGE YOURSELF

Saying that you should challenge yourself may seem a little contradictory to self-care, but it is a critical component of confidence building and self-growth. There are several ways to ensure that you keep moving forward and progressing in this new skill you have acquired.

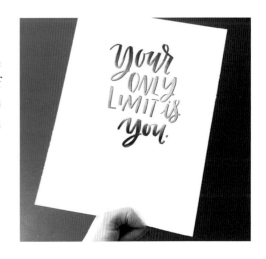

Never EVER ever EVER ever STOP Learning.

Document Your Progress

Keep samples of your work throughout your lettering journey. Documenting this progress is such an important part of reflecting on what you have improved on and how you have grown since the beginning. Documenting doesn't necessarily mean posting to social media (I'll get to that later), but make a point of keeping your sketchbooks and scrap paper. I treasure my very first hand-lettered alphabet that I created the same day I thought up my business logo. I also love looking back at my first sketchbooks to see how I've improved. When you see improvement, you are more likely to want to continue growing and learning while also feeling more confident.

Use Lettering in Your Everyday Life

I've said it before and I'll say it again, the more you use and practice lettering, the more you will learn and grow as a calligrapher and lettering artist. Find little ways to utilize your new skill outside of your regular lettering routine. This allows you to focus on self-care in all areas of your life, not just at your kitchen table each morning or night as you practice.

Join a Creative Challenge

If you are feeling the need to push yourself or running out of ideas for lettering practice, creative challenges would be a great fit! Just keep a lookout on Instagram and social media for different challenges. These challenges often entail writing or lettering a specific quote or responding to a prompt. I challenge you right now to join my creative challenge #letyourselfletter, which is all about finding time to letter every day (or as much as possible) for the sole purpose of self-care.

Find Your Creative Niche

The more that you create, the more inspired and experienced you will become. As you practice lettering and making, you will hopefully find your creative niche, an area that you are the best at creatively. Once you find this niche, make sure to keep using it and investing more time in what works best for you. For example, I love envelope lettering! My very first lettering job was a huge bundle of wedding

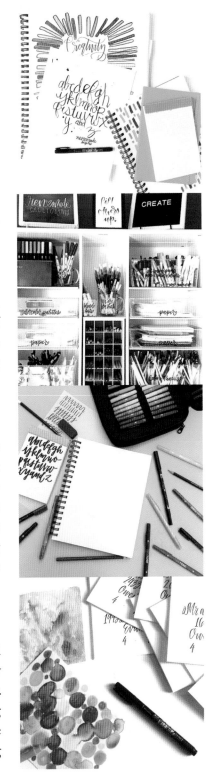

envelopes, and I was hooked after that. I love how formal and modern an envelope can be, and I still enjoy addressing envelopes more than any other lettering project to date.

Keep Learning

It's never too late to keep learning. There are so many books, resources, and online classes out there today, and this information is at your fingertips waiting for you to discover it. Keep allowing yourself to learn and grow. Tackle a new skill. See a watercolor book? Open it up and learn more about how to incorporate that skill into what you already create for your lettering. The more you keep learning, the more inspired you will become.

SHARE YOUR LETTERING

As you continue to grow in your love for all things lettering, it's definitely time for you to explore different ways to share your lettering with others and the world.

Gift Your Lettering

Good gifts can be difficult to find. Give the gift of your lettering to someone that you love. Whether it's a hand-lettered quote or project, hand-lettered gifts are personal and thoughtful. So, for the next holiday celebration, ponder what you could create as a gift to make someone smile.

Share on Social Media

We all know that social media is huge right now. One great way to get more eyes on your lettering work is to share it on social media. You can create your own Instagram account specifically for your lettering work (like I did) or just share on your personal account. Make sure to share what you create when you can. Don't get caught up in the number of likes, but share just because you love what you are doing and want others to see it too. If you share on social media, use #letyourselfletter and tag @renmadecalligraphy so that I can see what you have been creating.

 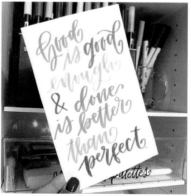 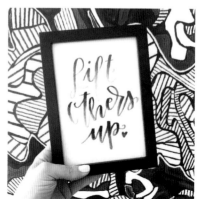

Sell Your Lettering

So you enjoy lettering for you, but have you thought about selling your lettering work to others? With website platforms like Etsy and Shopify right at your fingertips, selling your lettering work is definitely an option. If you are interested in selling, first pinpoint your personal creative niche. What are you really good at that others would buy? Consider selling hand-lettered goods or offering calligraphy services. It's important to note that having a business is quite a big endeavor, so make sure to do some research and fully grasp the responsibilities and obligations you would have as a business owner.

Teach Others

There is something amazing about teaching others the skill that you love with all of your heart. If you are obsessed with lettering and calligraphy like I am, you may feel a tug at your heart to start teaching others about the skill you love so much. Whether you plan to teach your best friend or hold a huge workshop, you'll have a blast teaching others too.

Letter in Your Community

Finally, make sure to branch out to your community. Whether you are lettering for the kids in your child's classroom or finding a reason to letter out in the wild of your community, take the time to use your lettering in any way, big or small, for those in your area.

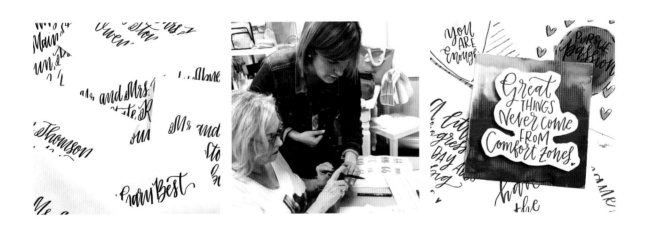

CLOSING LETTER

Hey, You!

Thanks for learning and lettering with me throughout this entire book. When I found lettering six years ago, my life improved so much, and I'm so grateful! So now it's your turn. You have everything that you need right here at your fingertips. Now you just need a routine for practice and time dedicated to self-care. So let yourself letter! You'll be amazed at how much you'll grow.

To put the importance of self-care in perspective, in the nearly six months it took me to write this book, *a lot* of life happened… I mean *a lot*! Not only did I find out we were going to have our third sweet baby boy (yay!), but I was diagnosed with type 1 diabetes, started the process of building a house, and worked as a teacher during a pandemic—all while being a mom and wife who strives for balance. Through all of the good and bad, stressful and chaotic, crafting this book helped me remember the reason I started lettering to begin with. It's not about learning a perfect skill or never making mistakes; it's really the quite the opposite. It's about taking the time for you, embracing the mistakes, and finding the balance and happy in everything that life brings. So if you take away anything, I urge you to really focus on yourself. Letter for YOU!

Keep creating and lettering. If you share any of your work, make sure to use the hashtag #letyourselfletter or #handletteringforselfcare and tag me @renmadecalligraphy. You've got this! So have fun, and happy lettering.

Hand Lettering for SELF-CARE

ACKNOWLEDGMENTS

Writing a book has always been a dream of mine, and I have been so excited to see it come to life. Though I have worked so very hard and poured my heart into writing this book to share my love of lettering with others, it is important to point out the amazing people and support that helped me mold this book into what it is so that others can learn and love lettering as I do. My heart is grateful for so many people!

To my husband, Michael: Thank you for your unwavering and unconditional love, support, and patience always, but especially as I wrote this book. You have always cheered me on and let me dream in my own little calligraphy world, and I'm so, so grateful for your encouragement and support.

To my sweet sons, Mac, Miles, and Myers: You are the light and heart of my life. I love being your mom and am constantly inspired by you. Always let yourself imagine, dream, and create. You can do absolutely anything you put your mind and heart to. My most proud masterpieces are the three of you.

To Mom and Dad: Thanks for gifting me that online calligraphy course and always pushing me to be the best version of myself. I value your support, kind words, and listening ears. I am so grateful to have found calligraphy and always think of the both of you when I pick up a brush pen.

To all of my friends and family: Thank you for the kindness and support you always show me and my calligraphy business. I am so blessed to have amazing people in my life.

To all of my students: Thanks for letting me teach you. Whether you were a calligraphy student or one of my "bobcats" that I have found joy teaching and learning with every day, please know that this book wouldn't be possible without you. You've taught me so much about myself and inspired me daily to be better, more creative, and more resilient. Always know that your dreams are within reach. As I say in class, "It won't be easy, but it will be worth it."

To all of my lettering and calligraphy friends, old and new, thanks for always being inspiring, encouraging, and supportive.

To Casie and the entire team at Ulysses Press, thank you so much for believing in me and guiding me through the unique, challenging, and fun process of writing this book. I so appreciate and value your support, patience, and advice.

ABOUT THE AUTHOR

Lauren Fitzmaurice is a left-handed calligrapher, lettering artist, and founder of Renmade Calligraphy. Through Renmade Calligraphy, she teaches lettering workshops, works with awesome brands, and gets to meet and make friends with people in the calligraphy community from all over the world.

An art minor in college, Lauren had always been creative and artsy, but it wasn't until January of 2015 that she took her first try at calligraphy. It had been an especially difficult year with her youngest son undergoing open-heart surgery at five days old. Lauren was exhausted, burnt out, and looking for something to focus on for herself. Lauren's mom purchased an online calligraphy class for her, and the rest is history. Learning this new skill not only helped Lauren focus on self-care and reflection, but it has also enhanced every area of her life and helped her get through other difficult challenges that life has brought.

When she's not lettering, Lauren is known as "Mrs. Fitz" to her elementary school students, "Mom" to sons, Mac, Miles, and Myers, and wife to husband, Michael. A lover of color, believer in glitter, and word nerd, Lauren's favorite way to take time for herself is creating beautiful letters and making a mess in her creative space with a brush pen in hand. She lives in Owensboro, KY.

Find more inspiration from Lauren at renmadecalligraphy.com and on Instagram at @renmadecalligraphy.

photo by Jacqueline Jordan Russell

Hand Lettering for SELF·CARE